IMAGES
of America

GERING, SCOTTSBLUFF, AND TERRYTOWN

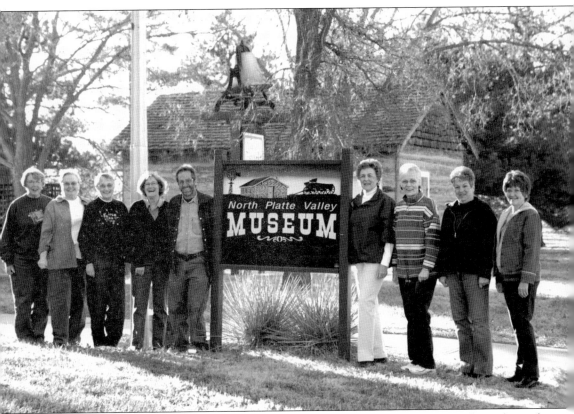

The collections committee of the North Platte Valley Historical Association are the authors of this book. Committee members are, from left to right, Gretchen Deter, Twila Enlow, Eleanor Shimek, Barb Netherland, Jim Headley (project coordinator), Jan VanNewkirk (committee chairwoman), Deanna Zweifel, Connie Kramer, and Pat Meyer. (Courtesy of Rick Myers.)

On the cover: The Graham Studio captured this very early view of Euclid Street in Gering in 1887 or 1888. Euclid is now known as M Street. Little is known about this image, as the back of the original is only marked "Gering in the early days." The first building in Gering was a post office, followed by a pioneer store, a general store, and the *Gering Courier* office.

IMAGES
of America

GERING, SCOTTSBLUFF, AND TERRYTOWN

North Platte Valley Museum

ARCADIA
PUBLISHING

Copyright © 2009 by North Platte Valley Historical Association
ISBN 978-0-7385-6074-8

Published by Arcadia Publishing
Charleston SC, Chicago IL, Portsmouth NH, San Francisco CA

Printed in the United States of America

Library of Congress Control Number: 2008940195

For all general information contact Arcadia Publishing at:
Telephone 843-853-2070
Fax 843-853-0044
E-mail sales@arcadiapublishing.com
For customer service and orders:
Toll-Free 1-888-313-2665

Visit us on the Internet at www.arcadiapublishing.com

CONTENTS

ACKNOWLEDGMENTS

We wish to acknowledge our tremendous debt to O. W. Simmons, A. B. Wood, H. A. Mark, and C. W. Bonham, photographers all, whose images record the very beginnings of the budding settlements of Gering and Scottsbluff. Their work forms the foundation of the North Platte Valley Historical Association/Museum photographic collection and supplied a large majority of the pictures for this book. We are also grateful to the following business and individuals who provided additional photographs, information, or proofreading for this project: Rick Myers, Jim Headley's private collection, Shirley and M. Rice, Jack Lewis, Gering Public Library, Scottsbluff Public Library, Lenore Heinke collection, Christian Studio, the Downey family and Downey's Studio, Scottsbluff Star Herald, Gering Courier, Scottsbluff Republican Newspaper, Terry Carpenter Inc., Scotts Bluff County Housing Authority, Jane Buckley, Charles Evans, Sherry Shank Pottorff, Webber family, Janet Bell Gifford, Charles Maxwell, John Baker, Connie Kramer, Cawley family, Virginia Cassels, Donna Micklich Hackman, Alexander Meyer family, Sandy Cook, Doug and Jean Tuttle, Carolee Reading Marker, Mark Masterton, the Joe and Lois Fairfield collection, Engstrom/Zitterkopf family, Genene Morrison, Hod Kosman, Willa Kosman, Gretchen Deter, Don Christensen, Bonnie Bolin, Tom Cozad, Richard and John Prohs, Dominion Construction, Lillis Grassmick, and Beverly Weadock.

Any errors are the responsibility of the authors.

INTRODUCTION

To travel again the trails of our youth / And harken to memory's giving, / To live for a moment those days of old, / Makes live today worth living. / We cannot wish for those days returning, / Nor ask for what life has taken; / But give us the joy, elusive still, / Ere from pleasant dreams awaken.
—*A City Was Born* by Charles S. Simmons, Scottsbluff artist and pioneer

If the North Platte River could talk, or at least the part of the river that winds through western Nebraska, it would tell a story of monumental historic importance. Evidence of occupation by early man dates back at least 5,000 years, and the early recorded history points to evidence that this region was occupied by nomadic tribes of Sioux, Cheyenne, and Arapahoe Indians. They followed bison and other abundant game, and all depended on the North Platte River and her tributaries for water.

Trappers and fur traders made their way along the North Platte River, hunting game and trading with "Plains Indians." Some married Native American women, raised families, and operated prosperous trading posts. A smattering of missionaries, headed for the Oregon Territory, wrote glowing reports of the rich, fertile soil. Then came the massive migrations to Oregon, California, and the Great Salt Lake, the migrations that ended a way of life for the Native Americans who roamed the Great Plains.

The Pony Express, the telegraph, the railroad, and finally the highways took advantage of the natural communication and transportation corridor afforded by the valley's topography.

Journal entries of those who passed this way in the early days paid tribute to the majesty of the surrounding landscape; the geologic formations still bear the names that were given by the trappers and the emigrants.

As the bison disappeared from the North Platte River Valley, massive herds of cattle could be found grazing on the prairies grasses. In the late 1880s, homesteaders began to settle in the North Platte River Valley, which was, at that time, part of Cheyenne County. Cheyenne County spanned most of the panhandle of western Nebraska, and settlers often had to travel over 100 miles to conduct county business.

The town of Gering, located on the south side of the North Platte River, was established in 1887 by several businessmen (mostly from Broken Bow, Nebraska) who gambled that the Union Pacific Railroad would build a line on the south side of the river near this town site.

Oscar Gardner, considered the founder of Gering, failed to get approval to name the town Vendome. Eventually the name Gering was chosen to attract a potential investor named Martin Gering, when the U.S. post office denied the city's use of Vendome.

Gering's main street was built atop the Oregon-California Trail. Later businesses favored a north-south location (now Tenth Street), and many of those buildings remain today.

Scotts Bluff County was created in 1888 after Cheyenne County was divided into five counties. It took two elections and a promise for Gering, aided by Millstown (a settlement about four miles east of present-day Scottsbluff), to secure the county seat. Gering's promise to Millstown to build a bridge across the river was fulfilled in 1889.

When the Chicago, Burlington and Quincy Railroad arrived on the north side of the river in 1900, there was a presumption that Gering's businesses and residences would move to the new town of Scottsbluff. Several Gering citizens did choose to relocate and due to the shortage of lumber, either floated buildings across the river or dismantled them to move them north across the bridge. Scottsbluff grew quickly. Much (but by no means all) of the vitality, work ethic, and the pioneer spirit that was so apparent in early Gering history moved across the river to Scottsbluff. The earlier arrival of the railroad worked to Scottsbluff's advantage, and the split in the early communities led to rivalries that continue today. Presently Scottsbluff's population is nearly double that of Gering's. A large majority of the retail businesses are located in Scottsbluff, which has become the retail hub for the entire region.

Sandwiched between these two larger cities is Terrytown. Terrytown was the dream of a very controversial and energetic man named Terry Carpenter. Terrytown was an experiment few could have envisioned. Out of swampland, Carpenter created a community that offered affordable housing and a variety of entertainment options. A new craze, pizza, was introduced at Terry's Carena, the Terrytown drive-in theater. Established in 1949, Terrytown gained city status in 2005.

Agriculture has been the mainstay of Gering, Scottsbluff, and Terrytown, providing farm related employment throughout the region. Irrigation, with its series of reservoirs, canals, and ditches, converted the high plains to some of the best farmland in the nation. While the agricultural economy does not experience the wild booms and busts of other sectors, it does provide a sense of stability that extends to business in general. Surrounding the cities, businesses, farms, and homes is a beautiful and unique landscape. Cupped by the Wildcat hills to the south and Scotts Bluff National Monument to the west, Gering, Scottsbluff, and Terrytown lie at the heart of a picturesque valley. Echoes of emigrants can be found in their journals and the legacy of early founders remains in the irrigation ditches, buildings, and businesses they built.

Thousands of cities in the country have rivers running through them. Like citizens of these cities, the people of Gering, Scottsbluff, and Terrytown travel through their towns without much thought of where one stops and the next starts. Newcomers and visitors are rightly puzzled by the situation. They shake their heads and ask why there are three cities in a three-mile span and wonder about a merger. However, students of the early history hear the echo of A. B. Wood's works, which stated "After the railroad arrived, it was thought or generally understood that Gering would move over to Scottsbluff, but trouble was caused because some in Gering were not consulted"; or they see the determination of C. H. Simmons, E. T. Westervelt, J. W. Carr, Warren Neff, and others who moved their homes and businesses to Scottsbluff to take advantage of the new railroad; or they cheer on Terry Carpenter as the underdog who took on big oil companies, made friends and enemies of local and state governments, amassed a fortune, established a town, and did it his way. The resilience required to build robust communities and prosperous farms out of prairies and swamps can only be imagined. Crops and irrigation canals are testaments to the unceasing physical labor supplied by farmers, their shovels, their horses, and their families. Creation of libraries, schools, and churches was the reward of diligent efforts on the part of the wives and mothers of the early founders. Today's vitality, apparent in Gering, Scottsbluff, and Terrytown, is testament to the enduring quality of all their accomplishments. All three cities have unique histories and fiercely independent identities. Over time, the cities have consolidated some services for economic reasons, and the idea of becoming one city has been visited and revisited many times over the years. Well, maybe someday.

One

GERING

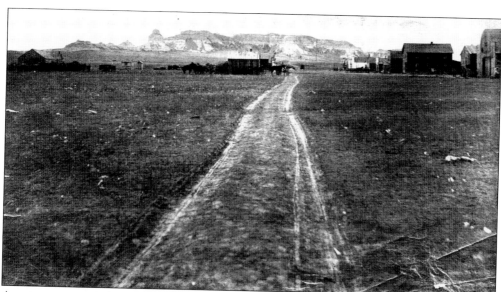

As pioneers traveled west during the 1800s, they searched for a better place to start a new life. Thousands from all over the world passed under the shadow of Scotts Bluff following the Oregon Trail. Emigrant trails often merged, and this photograph shows the path many followed on their way across the country. Gering is located at one of these convergences, though it was not until the late 1880s that Gering became a town. The fertile prairies and the hope of a railroad route attracted settlers who built a community that included a mosaic of customs and traditions brought from all over the globe.

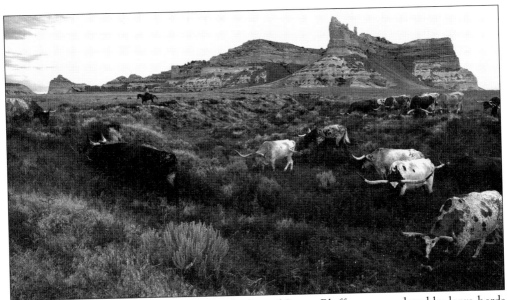

In the late 1800s, the vast prairies in the shadow of Scotts Bluff were populated by large herds of freely roaming cattle. The cattle industry was moving west to the fertile prairies where wealth was found in the untouched grasslands. Long before the homesteader arrived, the rancher was king. (Courtesy of Rick Myers.)

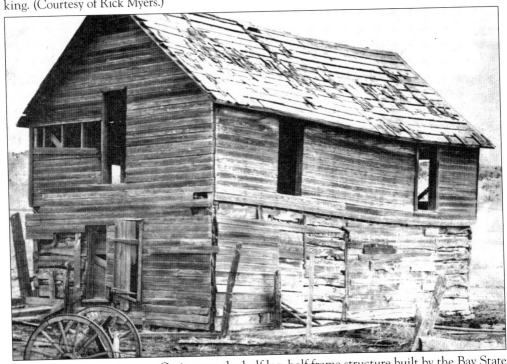

Pictured above at a site near Gering was the half-log, half-frame structure built by the Bay State Cattle Company near Pumpkin Creek. It was used as headquarters for their large cattle operation when Bay State Cattle Company started bringing cattle here in 1879. Another structure, built south of Gering in the early 1880s, was a preemption log house that was only occupied for a few months.

The founding father of Gering was a pioneer visionary named Oscar W. Gardner from Illinois. In 1885, Gardner came to the valley to explore the possibilities of settlement along the potential Union Pacific rail route. He saw the land at the base of Scotts Bluff as a "piece of paradise," and there he homesteaded prior to establishing the town of Gering in 1887.

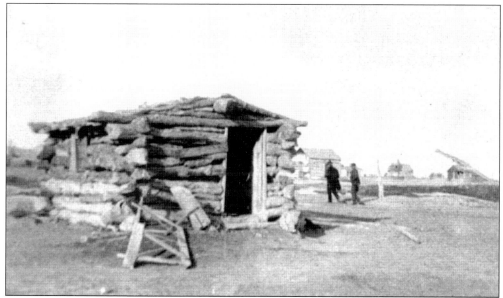

Gardner hauled logs from nearby canyons and helped Martin Bristol build this structure, the first building in Gering. It housed Gardner and was also used as the first post office since Gardner was the first postmaster. Gardner could not get official permission from the U.S. Post Office to name his town Vendome, so he named it Gering, in honor of Martin Gering, an early investor.

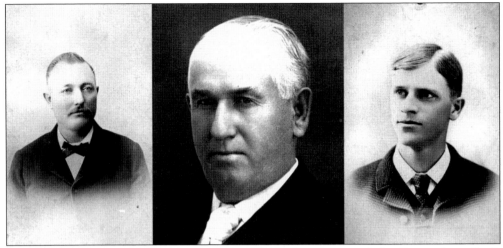

During the winter of 1886–1887, Oscar "O. W." Gardner organized the Gering Joint Stock Company with Frank Garlock, Martin Gering, C. W. Johnson, and George W. Trefern, many from Broken Bow, Nebraska. Thus according to A. B. Wood, Broken Bow became the "Mother of Gering." These men built businesses, established churches and schools, formed social groups, and provided an energetic nucleus for this young prairie town. Shown above are, from left to right, O. W. Gardner, Martin Gering, and C. W. Johnson.

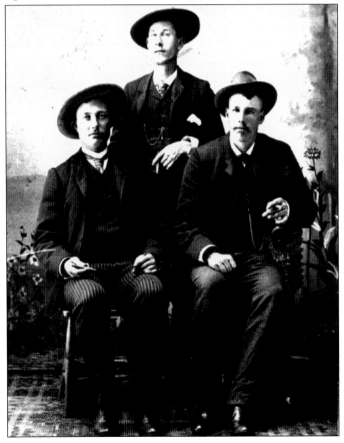

In May 1887, Gardner, Garlock, and Wood went to Sidney, the county seat of the huge Cheyenne County, to present a proposal to divide the county, hoping that Gering would become a county seat. Cheyenne County was eventually divided into five parts, and after some debate, their new county was named Scotts Bluff County. After much compromise, Gering became the county seat.

The first *Gering Courier* building was built with the help of Martin Bristol (left) in the spring of 1887. It was located a block west of what is now Tenth and M street (Euclid Avenue). Wood, the founder of the *Gering Courier*, is standing on the right in this photograph. There were about a dozen other businesses built during the summer of 1887.

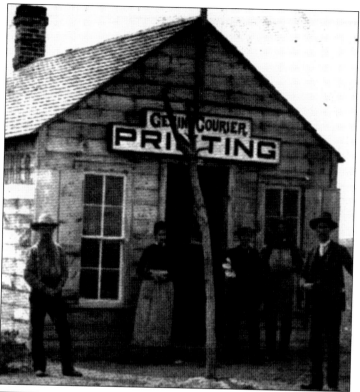

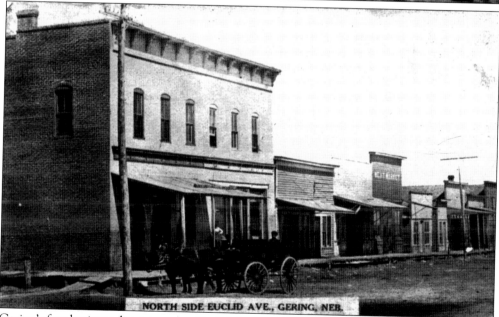

Gering's first business district was on Euclid Avenue (now known as M Street). The first brick structure was the Gering-Sayre building. Later that building became the Gering Mercantile and the Pastime Theater. The second *Gering Courier* structure was east of the Gering-Sayre building, and James H. Westerfelt added a grocery store, with E. C. Markland opening a general store to the east.

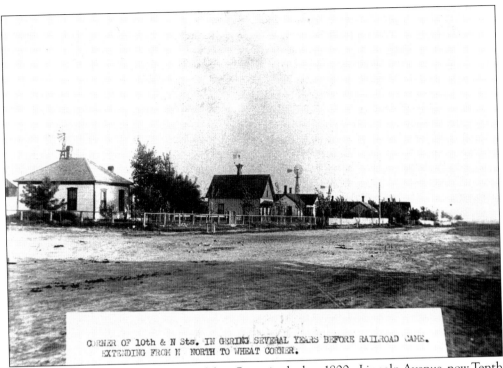

CORNER OF 10th & N Sts. IN GERING SEVERAL YEARS BEFORE RAILROAD CAME.
EXTENDING FROM N NORTH TO WHEAT CORNER.

Although Euclid Avenue was Gering's Main Street in the late 1800s, Lincoln Avenue, now Tenth Street, was an early residential area where many of the town leaders lived. This photograph, taken in 1890, shows the homes of Martin Gering, James Westervelt, Ed Sayre, Frank Beers, and Fred Enderly. It may be noted that the number of windmills nearly equals the number of residences.

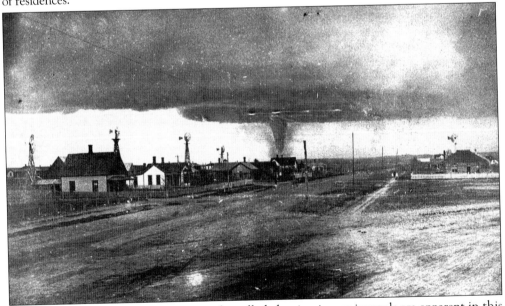

The perils of weather on the prairie so often alluded to in pioneer journals are apparent in this photograph of Lincoln Avenue, taken on May 24, 1899. Ominous black skies and three funnel clouds hang over the town, appearing to head straight down the streets of Gering.

14

This business district photograph highlights the grand Gering Hotel and the Commercial Hotel to the south, which is still standing on the southeast corner of Tenth and N Streets. Much has changed since the earlier 1899 photograph of windmills and picket-fenced houses.

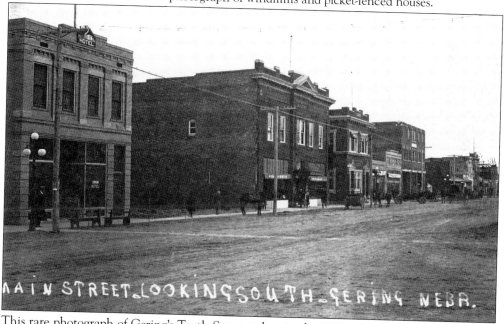

This rare photograph of Gering's Tenth Street, taken in the 1920s, shows the old Swan Hotel, later the city office building, on the southeast corner of Tenth and O Streets. One can also see the fraternity building and the *Gering Courier* building constructed in 1915. Note the mix of horses tied to the power poles and automobiles parked along the dirt street.

Martin Bristol was the town's first builder. He built the first *Gering Courier* building, the first post office, and many of the first homes. After returning from travels in 1893, he took a job at the Carr and Neff Lumberyard. He owned a farm loan company with A. B. Wood and was postmaster from 1894 to 1895. Always helpful, he assumed a quiet and substantial position, striving for a stronger community.

Edward Sayre had the first general store in Gering. After a time, he purchased the Keefer, Hastings Store Company, which was first owned by T. S. Franklin and Frank Garlock. He restocked and upgraded the store, then renamed it the Golden Rule. He married Wood's sister Margaret (Maggie) and had four sons and five daughters. Later A. B.'s brother Shan married Sayre's sister Mary.

Born in Canada, Miles Huffman and his wife, Julie, and two children moved to Gering in November 1889. He set up office and became a practicing attorney at 1317 Tenth Street. He served as county attorney two terms and later became president of the Scotts Bluff Bar Association. He and Julie were charter members of the Baptist church and were active in many church activities.

Benjamin Gentry, an abstractor, worked as secretary of the Gering National Farm Loan Association and was the first Scotts Bluff County clerk. He married Cora Johnson, his deputy clerk, and they had three sons and one daughter, Bernice Elizabeth. The sons were Dr. William J. Gentry; Harold E. Gentry, a county surveyor; and Dr. Max Gentry. Max was a medical missionary in China and was in charge of a large Methodist hospital there.

George Luft arrived in the valley in May 1887, where he formed a business partnership with Dr. S. H. Charlesworth to open Gering's first drug store, then a dry goods store. He was an accomplished musician who had previously directed bands at Germantown and Seward. He organized the Gering Cornet Band. He also served as treasurer of Gering's first school district in July 1887.

Ed Gering

Edson Gering, the only son of Martin and Sarah Gering, came to the valley in 1888 and worked at the Gering-Garlock Implement and Hardware Store. He opened the Pastime Theater in the former Martin Gering grocery store, operated a stage line, and carried mail between Scottsbluff and Gering. Edson married Nellie M. Winner, and they had seven children. Edson often called the square dances at social affairs.

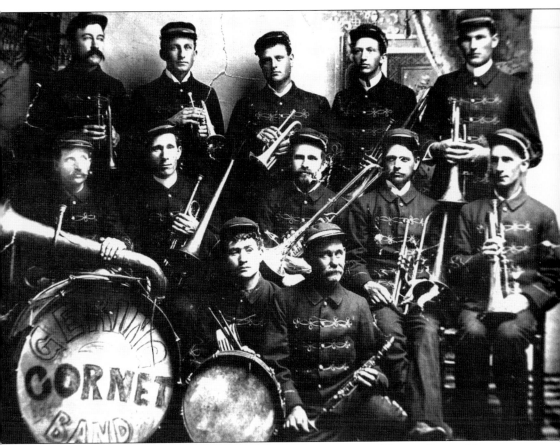

Music played a big part in the social fabric of the new community of Gering. Pictured here are members of the Gering Cornet Band. They are, from left to right, (first row) J. W. Richardson, grocer; and Joseph Kingman, pioneer homesteader; (second row) Albert C. Stear, associated with the Sayre general store; A. B. Wood, *Gering Courier* owner; Dr. Joseph H. Miller; John Burton, hardware dealer; and Edson Gering, mail carrier and operator of the first motion picture theater; (third row) George Luft, bandleader and owner of a dry goods store; Louis Luft, George's brother and a harness-maker; Clarence W. Bonham, early photographer; Harry J. Wisner, printer at the *Gering Courier* and later editor of the Scottsbluff newspaper; and Claude H. Westervelt, future mayor of Scottsbluff. At the first county fair and before the band was organized, an impromptu band was put together with 10 instruments borrowed from Kimball, Nebraska. It is said that whatever they lacked in tone and talent, they made up for in enthusiasm.

Dr. Georgia Arbuckle Fix was the first woman to graduate from the newly formed College of Medicine of Omaha in 1883. She came west in 1886 and for a time was the only doctor serving pioneers from Camp Clarke to Fort Laramie. Other early physicians were Dr. Thomas S. Franklin, a member of the Franklin and Garlock Firm; Dr. William H. Charlesworth, partner of George Luft in Gering's first drug store; and Dr. Birney, who practiced here for a short time. Dr. Fix, however, had the most lasting impact on the valley. Her home, pictured below provided her living space, her office, a boarding house, and a sanitarium.

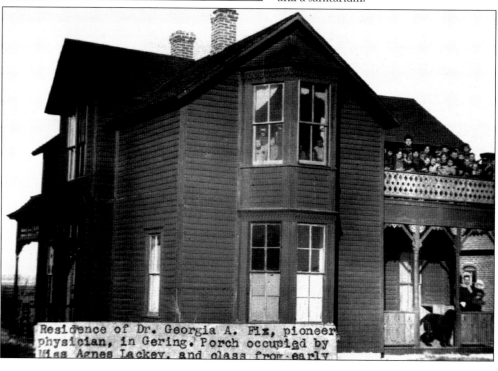

Residence of Dr. Georgia A. Fix, pioneer physician, in Gering. Porch occupied by Miss Agnes Lackey, and class from early

Idah McComsey worked for the *Gering Courier*, served as a postal clerk, and wrote a news column. She also took care of the doctor's office for her neighbor and good friend, Dr. Fix, when she was out on calls. McComsey had lots of tragedy in her family, never married, and had one true love. He lost his life in a blizzard while in route to Cheyenne.

Lillian (Brashear) Wolt was chairperson of the first women's club, which she established with Margaret (Wood) Sayre and Jean (Brashear) Wright in 1895. They started a library with their own books, raised money to fence the cemetery, and helped build churches. The club provided mental stimulus and entertainment for the women and their families through their planned events to raise funds. Records of those meetings were donated to the North Platte Valley Museum.

21

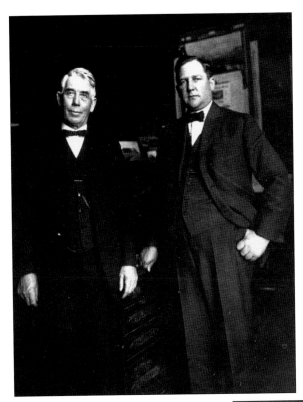

Shown here are Robert F. Neeley (left) and A. N. Mathers. Neeley was the first president of the Gering National Bank which was established in 1910. Mathers became president of the Gering National Bank when he bought controlling interest in 1913. He was also Gering's first mayor in 1916.

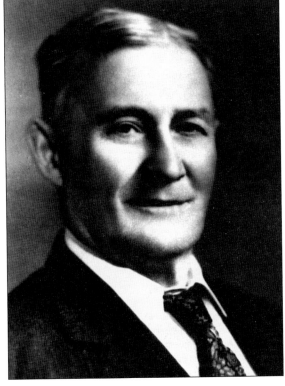

In 1886, Ed Cromer moved from Illinois to homestead near Gering. He was a master farmer and helped develop irrigation in the valley. Cromer was a charter member of the Gering Methodist Church and held the first church service in his home. He was secretary of the first Scotts Bluff County Fair and served three terms in the Nebraska legislature.

A. B. Wood was one of the early founders of Gering. He established the *Gering Courier*, which was the earliest and most prominent newspaper in the North Platte Valley. Wood arrived in Gering in 1887 and printed the first paper within a matter of days. The North Platte Valley Museum has a large collection of Wood's original papers.

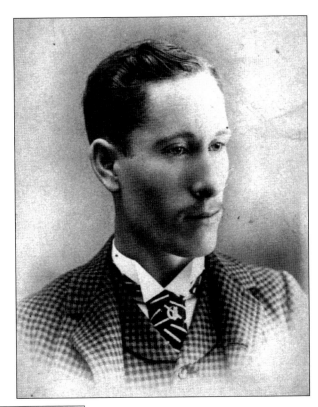

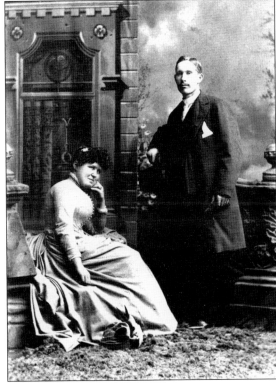

This photograph, taken in 1888, is one of Wood and his wife, Maggie Claypool. A. B. met Maggie, a 20-year-old schoolteacher from Cozad, Nebraska, when she came to town to visit the niece of one of Wood's friends, Martin Gering. Maggie and A. B. were married on October 11, 1888. Their son, Warren Claypool Wood, took over as publisher of the *Gering Courier* after the death of his father in March 1945.

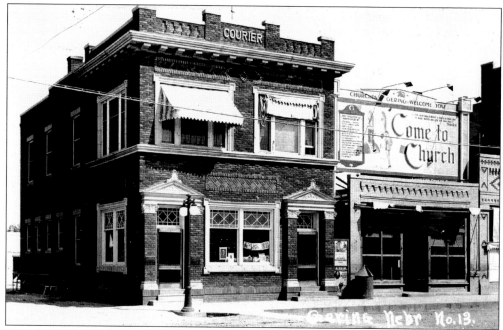

This *Gering Courier* building, constructed in 1915, was the third building to house the publishing business of A. B. Wood. It is located in the central business district between N and O Streets and is still the home of the *Gering Courier*. This building and the A. B. Wood family business were entered in the National Register of Historic Places on October 15, 2004.

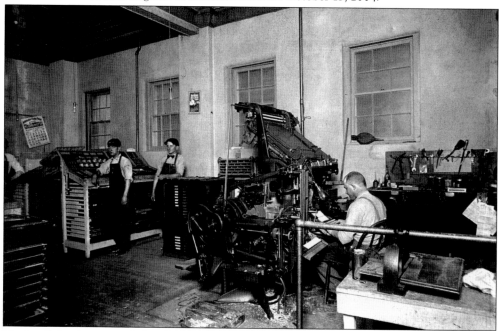

Much of the interior of the *Gering Courier* building retains its original dimensions. This photograph, taken in 1916, is of the composing room, showing state-of-the-art (for 1916) printing equipment that is now on exhibit at the North Platte Valley Museum. The tin ceiling has been restored and is still part of the *Gering Courier* building.

The first bank in Gering, the Bank of Gering, was founded in July 1887 by Martin Gering even before he arrived in the town named for him. The bank's business was conducted by the head cashier, C. W. Johnson (shown here), who was instrumental in convincing Martin Gering to invest in Oscar Gardner's town. It was not a large bank, but it was the first official bank in the county.

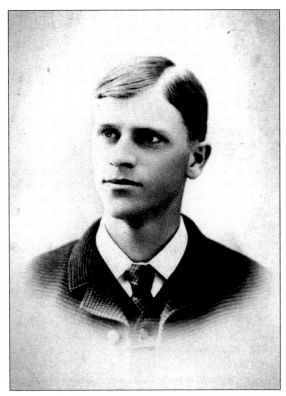

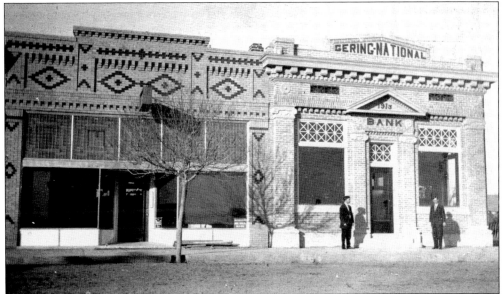

Gering National Bank was organized in April 1910 by the Ostenberg brothers. They leased the Bonham building, which had been a photography studio and a honeybee supply store. In 1913, the Gering National Bank building was built across from the soon-to-be-built *Gering Courier* building. The bank was remodeled several times and finally moved to a new location and a new building at 1600 Tenth Street. The 1913 building (above) was razed, and the Valley Bank and Trust building now stands in that location.

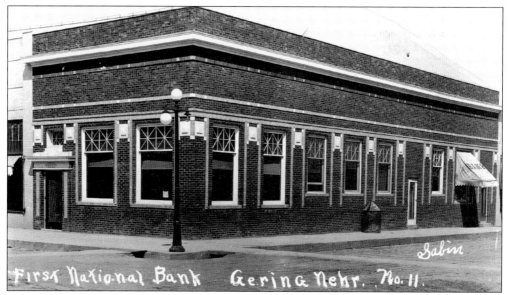

The second bank in Gering was the First National Bank. It was founded by Henry M. Thornton in 1902 and was located on the corner of Tenth and N Streets where the Union Bar is now located. Thornton later had architect Jens Petersen build a large two-story building at a new business district on north Seventh Street. In 1916, the bank moved again into the building shown above on the corner of Tenth and O Street. The First National Bank failed in 1924.

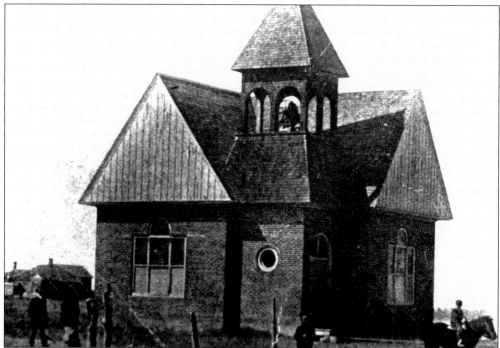

The First Christian Church of Gering was organized in 1890 by O. A. Slafter. The members met in an upstairs hall until it was destroyed by fire. They then built the structure shown above in 1900. It was located on a corner of Courthouse Square and, when a new courthouse was needed, the First Christian Church of Gering moved south and west to their new location.

The Baptist church was one of the earliest organized churches in Gering. Dr. Benjamin Brisbane preached the first sermon in 1887 in Martin Gering's log house. The First Baptist Church structure was erected in 1889.

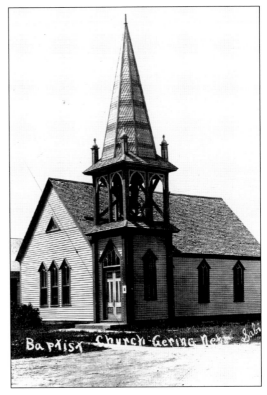

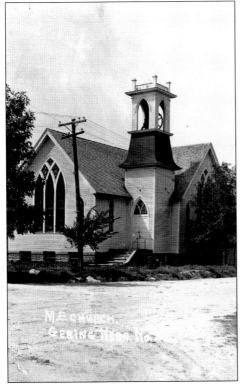

The Methodist church was organized in 1889, but the first sermon was delivered by Rev. A. A. Amsbary in 1887. In 1886, R. M. Hanks and E. P. Cromer held Sunday school in an old log cabin. The first church was a 24-by-40-foot structure. The building seen here was built in 1909 and added to in 1925.

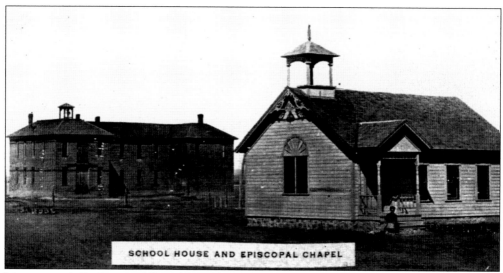

SCHOOL HOUSE AND EPISCOPAL CHAPEL

Missionary A. R. Graves, followed by Bishop George A. Beecher, formed the first Episcopalian society in Gering in 1892. The services were part of a 250-mile circuit route. St. Timothy's Church (shown above) was built in 1904 with the funding help from such leaders as Dr. Georgia A. Fix. The so-called "Mather's Annex" was added later.

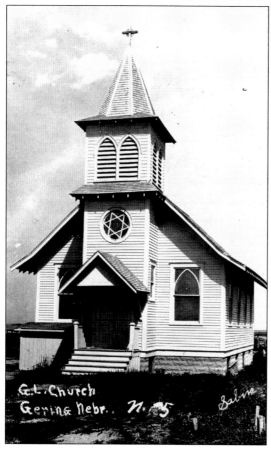

The German Lutheran Church was built in 1890 and was later occupied by the Gering Zion Church. It was one of the oldest buildings in Gering.

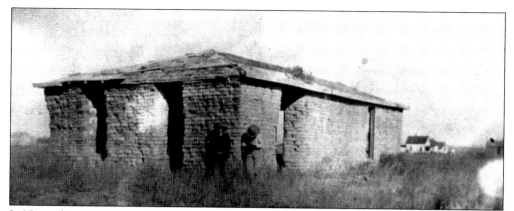

In November 1888, Scotts Bluff County was formed and a special election was held to select the location of a county seat and county officers. Joseph M. King was elected county judge, but the county seat location was not settled. Judge King's sod house, located near Castle Rock, was not only his home but served as his chambers and courtroom.

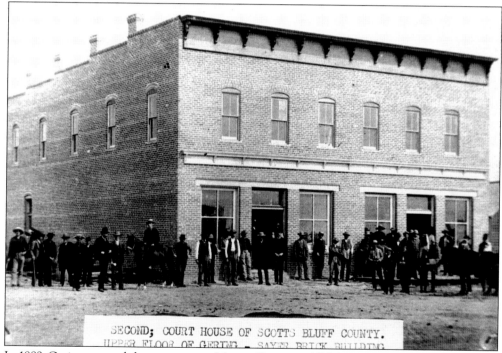

SECOND; COURT HOUSE OF SCOTTS BLUFF COUNTY.
UPPER FLOOR OF GERING – SAYRE BRICK BUILDING

In 1889, Gering secured the county seat. Martin Gering and Ed Sayre agreed to use three offices in the upper floor of the Gering-Sayre building (above) for county offices. In August, county clerk Ben Gentry, Sheriff Thomas Fanning, and county attorney W. J. Richardson moved in. Treasurer Frank Beers moved the county safe into his hardware store downstairs and transacted county business from there.

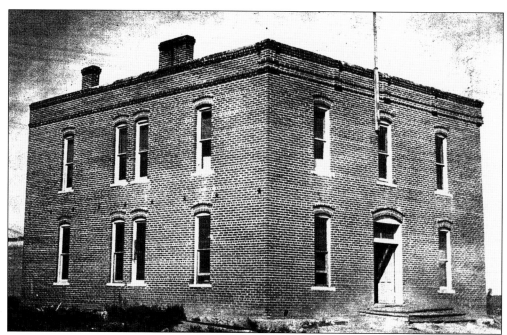

The Gering Joint Stock Company deeded a block of land where Legion Park is today and a log jail and courthouse (above) were built on that site. During the years 1910 through 1919, controversy rose again and again about the location of the county seat. As Scottsbluff began to rapidly grow (partially due to the Chicago, Quincy and Burlington Railroad), many Scottsbluff residents believed their town should become the new county seat.

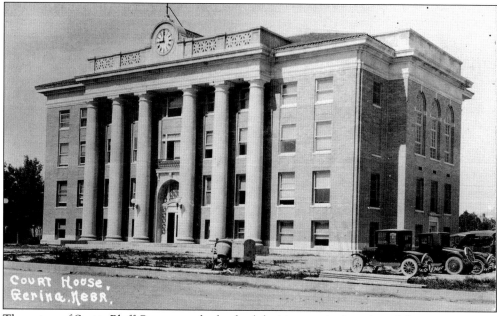

The voters of Scotts Bluff County made the final decision on the location of the county seat in March 1919. Once that issue was settled, the old courthouse was sold and a new site was selected on Gering's main street. The old site became a park and the cornerstone for the new courthouse was laid in October 1920. Scotts Bluff County still operates from that building.

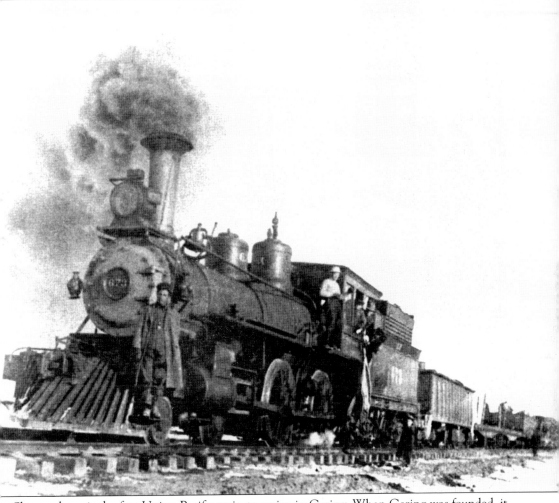

Shown above is the first Union Pacific train to arrive in Gering. When Gering was founded, it was supposed to be a railroad town. Talks about laying track on the south side of the North Platte River began as early as 1885. Oscar Gardner saw the potential for a thriving town and moved west to become part of the western railway movement. There were assurances given in 1900 that Union Pacific would come to Gering, but it was 10 more years before the railroad arrived.

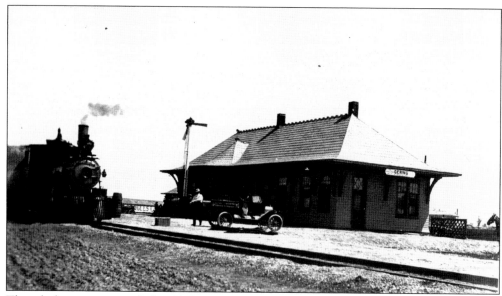

Though the town was settled in 1887, it was not until 1909 that the Union Pacific purchased the right-of-way for a rail route from Northport to Haig. In 1910, the first rails were laid into Gering, and the first train arrived on October 8, 1911. On December 8, 1911, the first train station in Gering opened, and George Leonhardt was the first agent.

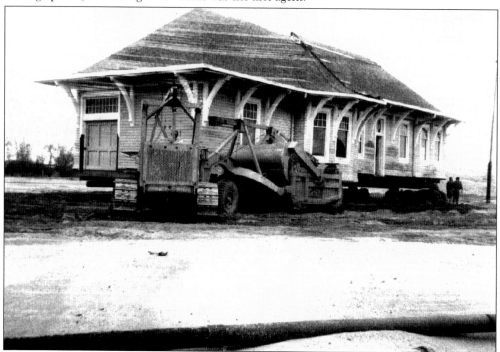

There was a great deal of competition between the businesses in "Old Town," now Tenth Street, and those of "Scab Town," which is now Seventh Street. Originally the Union Pacific train station was located near Scab Town, but in 1913, the Union Pacific ordered it moved to Tenth Street. This was done quickly to avoid a full-scale fight between the two business districts. This photograph shows the process of that move.

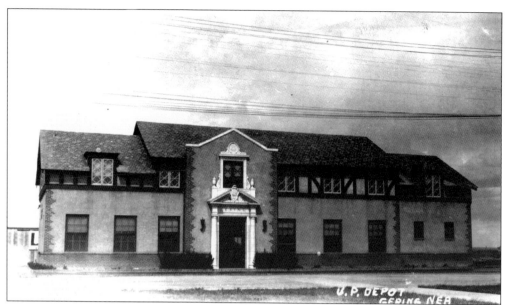

In 1928, the Union Pacific built a new passenger and terminal station on Tenth and U Streets. In 1971, the last passenger train left Gering, and there was no longer a need for the depot. The depot was converted into Wildlife World Museum and is still a popular attraction in Gering.

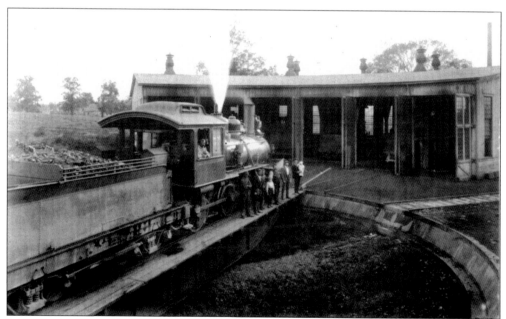

In 1928, the Union Pacific built a round house on Seventh Street just north of the railroad tracks. It had five stalls and multiple sets of tracks. The round house, used for making engine repairs, was an ingenious design allowing locomotives to be moved on a turn style that allowed for functional and efficient repairs. The turn styles could also be used to easily turn engines in the opposite direction.

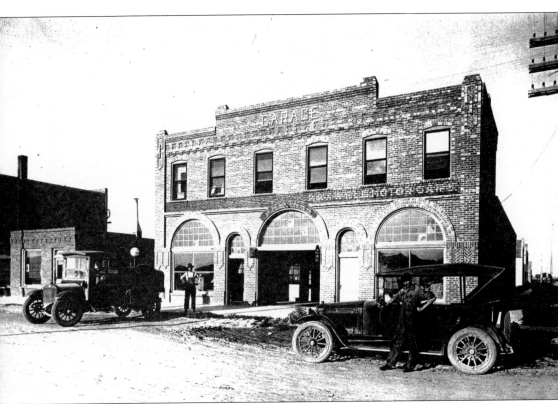

The Ware Brothers' Garage (above) was built between 1911 and 1913. It was located between R and S Streets on Seventh Street. In the early 1900s, there was a second business district in Gering, which was the result of a dispute between O. W. Gardner and H. M. Thornton. Hoping to get the Union Pacific to build its Gering depot on his property, Thornton laid out a business section on Seventh Street while Gardner was determined to keep the primary Gering business district on Tenth Street. Gardner referred to Thornton's business section as Scab Town. In addition to the depot, one of the Scab Town's primary businesses was a two-story hotel housing the First National Bank on the first floor. There was a mercantile, barbershop, a gas station, and a dozen or so other businesses. When the Union Pacific depot was moved, Thornton sold his investments and left Gering. Today that block is owned by Tom and Donna Cozad, owners of Creative Signs by Cozad.

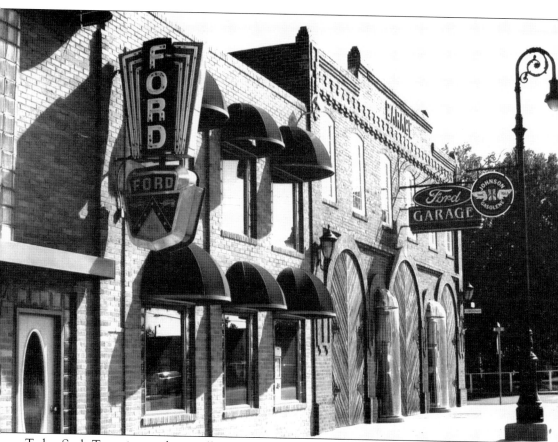

Today Scab Town is a striking collection of buildings preserved by Tom and Donna Cozad. They operate a sign company out the south side of the block where the former Ware Brothers' Garage was located and have refurbished the top floor of the north end of the block as their private residence. The Cozads have preserved both the interior and exterior features of the early buildings. The old Scab Town garage is still recognizable for its unusual architectural features.

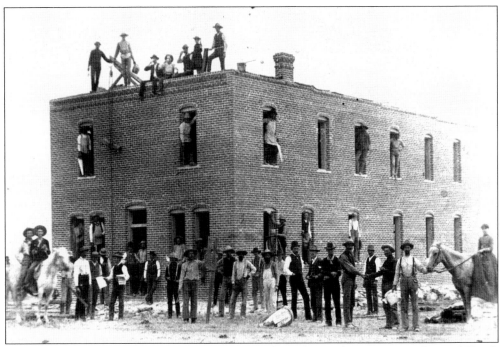

The Commercial Hotel, shown above, was located on the southeast corner of N and Tenth Streets. It was built in 1889, only two years after the founding of the city. The structure still stands on that property.

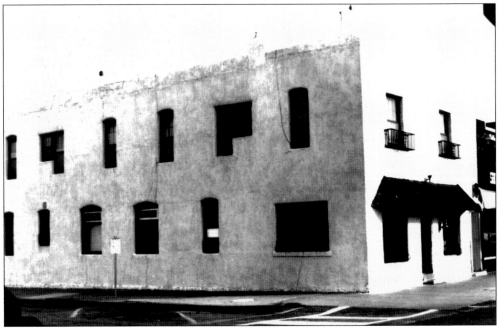

This photograph is a more recent picture of the old Commercial Hotel. The building was covered with stucco and became the Bender Apartments. For many years, Bender Shoe Repair operated its business on the first floor. The top floor of the building is still being used as apartments, and other businesses have occupied space on the main floor.

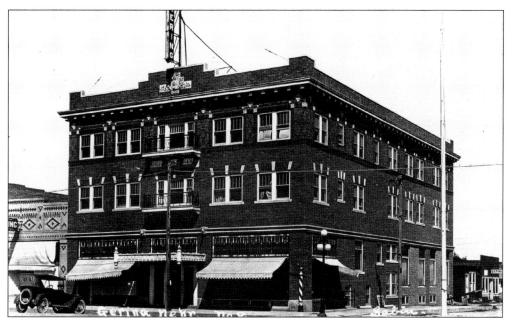

Shown above is the three-story, grand old Gering Hotel. It was constructed on the northeast corner of N and Tenth Streets in 1920. It had a quaint restaurant popular to many Geringites. Notice the barber pole indicating the presence of a barbershop in the lower level of the hotel.

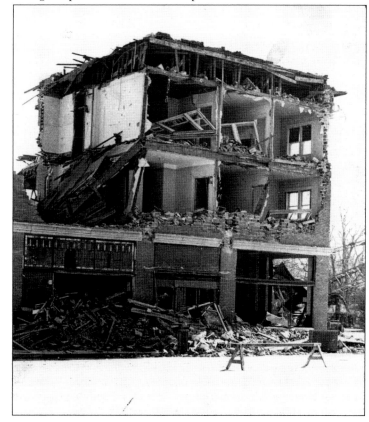

This photograph shows the destruction of the Gering Hotel. It was replaced by McCosh Drug, which was built on that site in the early 1970s. It now operates as U Save Pharmacy. At this site, there is nothing left of the grand old Gering Hotel, which was an important part of Gering's history.

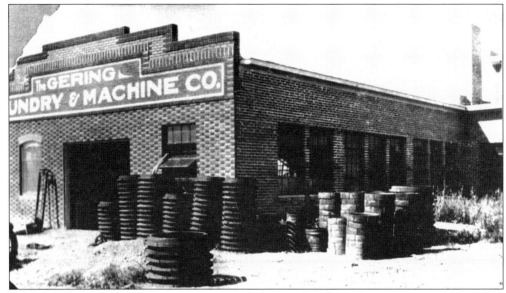

Associates C. E. Conn, Charles Lyman, and O. W. Gardner built the Gering Foundry in 1917. The foundry produced castings for cities, irrigation projects, and industries and was the only such industry within a 250-mile radius. Ownership changed hands several times until it was purchased by Julius Sisch. The foundry operated until 1973, when Howard Sisch converted it into a machine shop. Western Area Power Administration purchased the Sisch building in 1987. The image above shows the stacks of manhole covers that were a specialty product of the Gering Foundry.

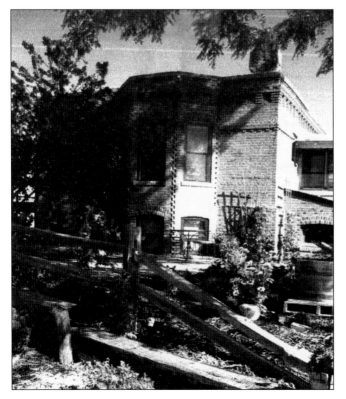

Shown at left is the original home of Severin Sorenson, who was the owner of the Gering Brick Factory. The house is now on the National Register of Historic Places. The factory provided bricks for many of the first structures in Gering. Due to high labor costs, the brick factory, located just west of today's Gering High School, closed in 1941.

The Gering Mercantile store was founded prior to 1919 when the owner and manager was Frank Birchell. The building, seen above, was on the southwest corner of Tenth and O Streets. The Gering Mercantile provided a variety of products. Everything from groceries to men's and ladies' clothing could be found there. The building now houses the Main Street Appliance Store.

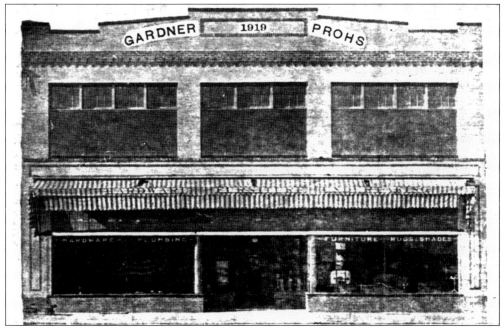

The home of the Prohs Brothers Company (above) was built in 1918–1919 by Gardner, the father-in-law of Edward Prohs. The Prohs brothers, Edward and Otto, operated a hardware, plumbing, furniture, and appliance business for many years. Later Richard Prohs, son of Otto Prohs, took over the operation and continued to run the business.

Thorval John Lockwood was considered a mechanical genius. He founded the leading factory for vegetable handling equipment, which he located in Gering. He was one of Gering's great philanthropists, active in scouting, church, schools, and many other fine works now sponsored by the Lockwood Foundation. According to the *Lincoln Sunday Journal and Star*, Lockwood was "a quiet, unassuming man, with deep religious convictions."

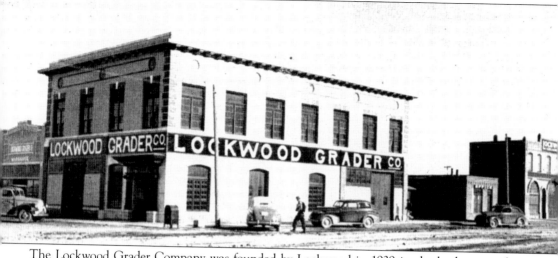

The Lockwood Grader Company was founded by Lockwood in 1939 in the back room of an old building on Seventh Street in Gering. Lockwood bought one building after another until he owned an entire block of buildings that had earlier been labeled Scab Town by the town businessmen who wanted to keep the business district on Tenth Street rather than on Seventh Street. Lockwood built potato equipment and invented many machines related to the potato industry. They became a leading producer of vegetable handling equipment and eventually had factories in many states and foreign countries.

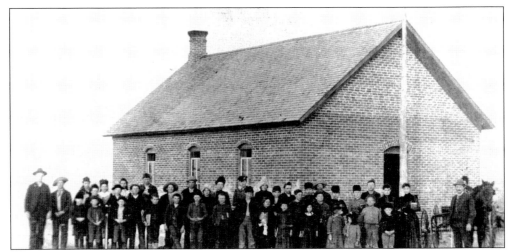

The Gering School District was organized in July 1887. At that time, school was held in a sod building with a dirt floor and little lighting. This first brick structure was built in 1889, just east of the present Methodist church. Ida Cromer was the first teacher.

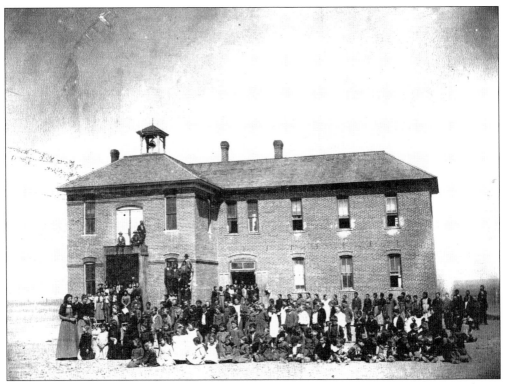

Gering's second school was built about 1892 when the town was still very young. It was larger and constructed of brick. It was located just west of the present-day Gering Junior High School. Ed Cromer was the principal and his wife, Ida, was a teacher for 27 years.

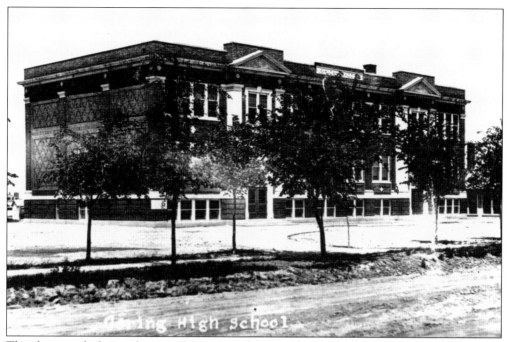

The photograph shown above is of Gering High School, built in 1918 and located on Ninth and Q Streets. Several additions were made to the building, but the signs designating the "Girls" entrance and "Boys" entrance always remained. The building was razed when additions were made to the present-day junior high school.

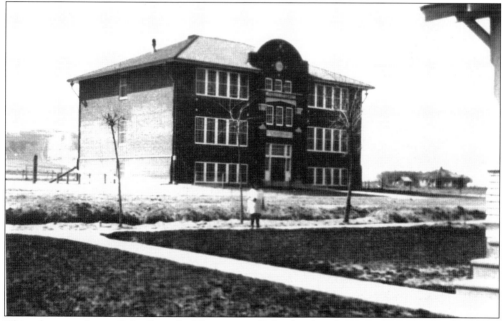

This photograph is of the Lincoln Elementary School, often known as "West Ward." It was much like McKinley Elementary, known as "East Ward." Lincoln Elementary is still in use, but McKinley Elementary closed in the 1990s. Note in the photograph that there are no buildings west of the school and the Scotts Bluff Monument is clearly visible.

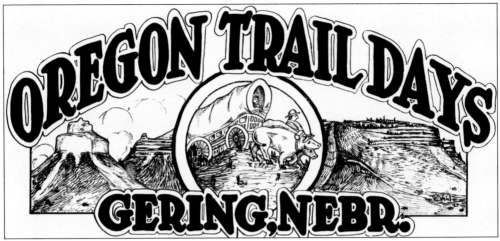

Oregon Trail Days has been a part of Gering since 1923. It has grown from a one-day parade to an annual four-day event that attracts thousands of people from all over the country. A. B. Wood was one of the original planners of the celebration, and his young son, Warren, designed the Oregon Trail Days logo when he was only 15. That logo, seen above, is still being used today. One of the early parades, seen below, shows the pride of the Native Americans by participating in the celebration.

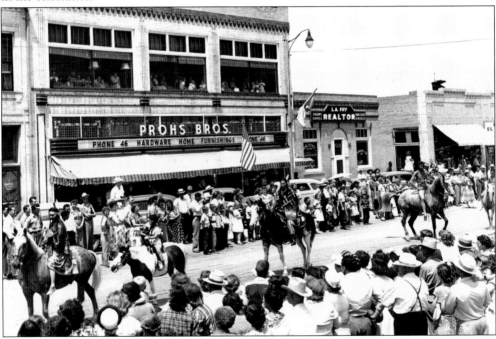

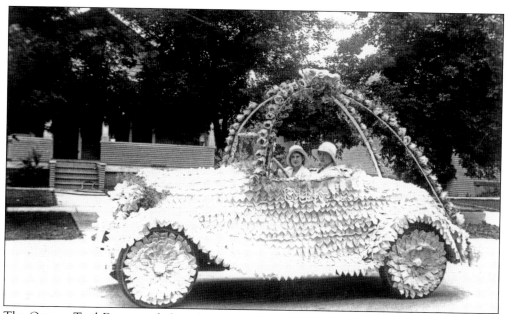

The Oregon Trail Days parade has always included a variety of entries. Some of the favorites have been the decorated floats, and throughout the years, there has been about every type of float imaginable. The "fluffy" little car, shown above, is one of the smallest floats participating in the early years of the parade.

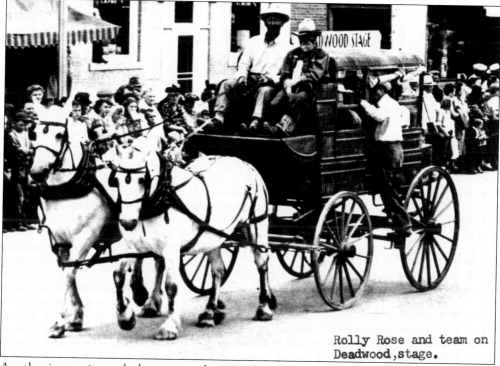

Rolly Rose and team on Deadwood, stage.

Another interesting early day entry in the annual Oregon Trail Days parade was the Rollie Rose entry. Rose and his team of horses are seen here leading the parade in 1929. In a rural area such as Gering in 1929, one's horses were much a measure of one's stature in the valley.

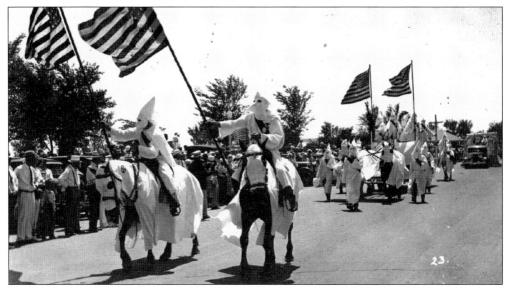

In August 1912, the Ku Klux Klan (KKK) organizer was in Gering and Scottsbluff, interviewing local businessmen and churchgoers, encouraging them to join the "white-coweled gentry and the establishment of Klavern." A group was organized in this area, and it was reported that the KKK was very active in western Nebraska. In the 1920s, the local Klansmen rode in the Oregon Trail Days parade.

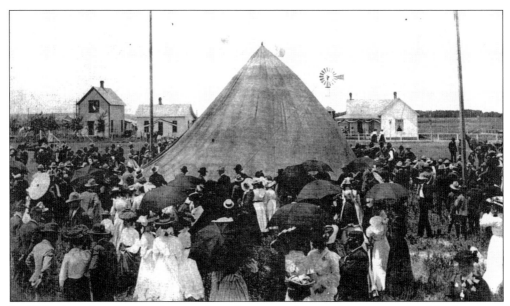

In 1910, when this photograph was taken, Gering was home of the county fair. The large tent seen here was the "Creatives Tent" at the fair grounds two miles east of Gering. The first settlers cherished any chance to show off their products and gather with their neighbors. They dressed in their very finest even though the fair grounds were weedy, dusty, and dirty.

The Lyceum was an organization that provided public lectures, concerts, and other performances. A. B. Wood, A. N. Mathers, Charles Lyman, and other founders brought such events to Gering as early as 1916. They worked with the Midland Lyceum Bureau to bring popular entertainment to the town. The 1916–1917 Lyceum season brought the Varalla-Gross Orchestra to the area for the pleasure of Gering's citizens.

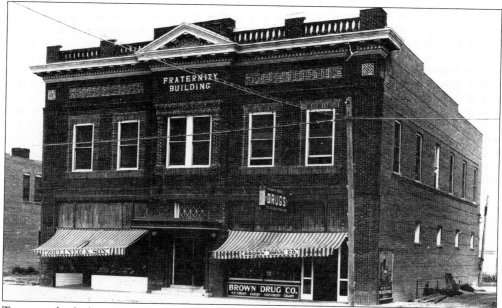

Two months before the formal opening of the new *Gering Courier* building in 1916, it was announced that the Masons and Odd Fellows would build a lodge. This two-story fraternity building was built north of the *Gering Courier*. The upper level was used as a meeting place, and the lower level housed two businesses. Zoellner and Son on the north and Brown Drug on the south were the first occupants.

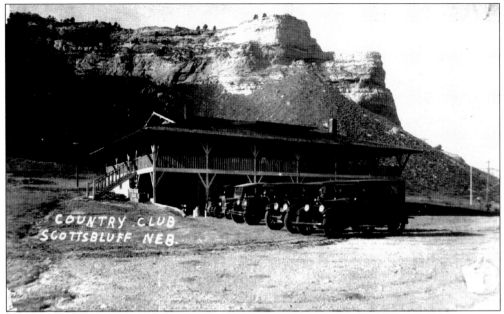

In 1916, the Scotts Bluff Country Club was located in Gering at the base of Scotts Bluff National Monument. The original structure, shown above, opened on September 22, 1916. It had dining and dancing facilities as well as a nine-hole sand greens golf course. Annual dues were $10 in 1916.

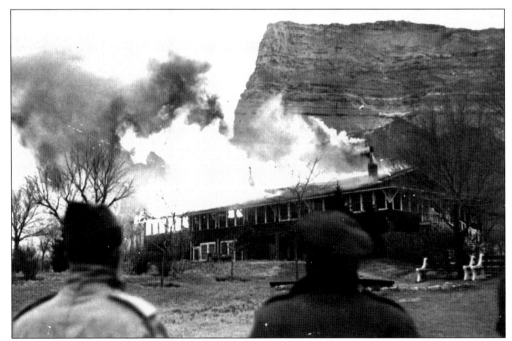

On December 19, 1946, the Scotts Bluff Country Club was destroyed by a fire that was caused when Christmas decorations near the fireplace ignited. Because of inadequate supplies of water and a strong wind, the fire fighters were unable to save the building, which was completely engulfed with flames.

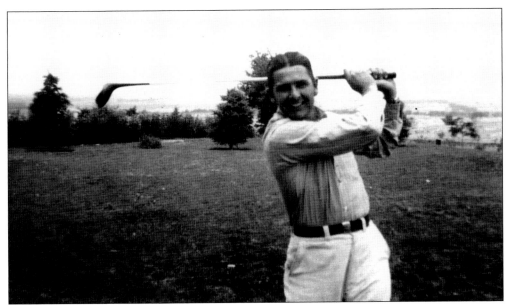

Bud Kinney was the golf professional at the Scotts Bluff Country Club from 1936 to 1940. He was from Del Rio, Texas, and came to the country club highly regarded as a talented golfer. He qualified five times for the U.S. Amateur Golf Tournament. Kinney started the Oregon Trail Golf tournament, which still is hosted annually by the Scotts Bluff Country Club. (Courtesy of Bonnie Bolin.)

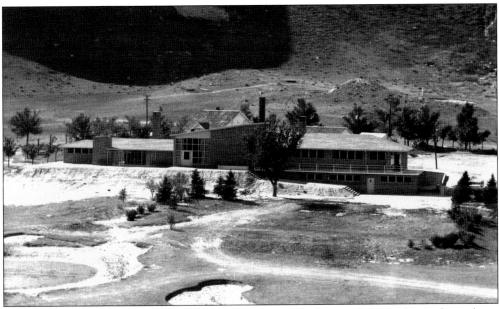

After the original country club was destroyed by fire in 1946, a new brick building, shown here, was built in the same location. It had a clubhouse, pro-shop, golf course, and swimming pool. There was fine dining and a ballroom. The country club later moved from that property and relocated near the town of Scottsbluff.

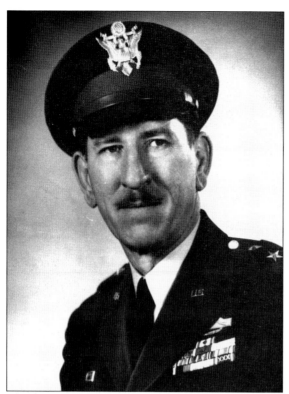

Warren Claypool Wood was the son of A. B. and Maggie Wood. He took over the publishing of the *Gering Courier* after the death of his father in 1945. This photograph was taken when he was major general of the Nebraska National Guard. He was a highly decorated hero of World War II.

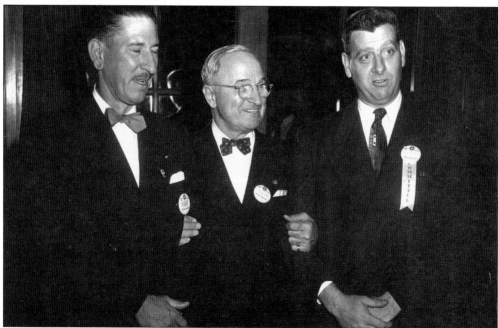

Warren Wood was very active in Gering and in the state of Nebraska. This photograph is of Warren Wood and Harry S. Truman. It is believed to have been taken at the National American Legion Convention. Wood was the state commander of the American Legion. He was also president of the Nebraska Press Association and involved in a myriad of community activities.

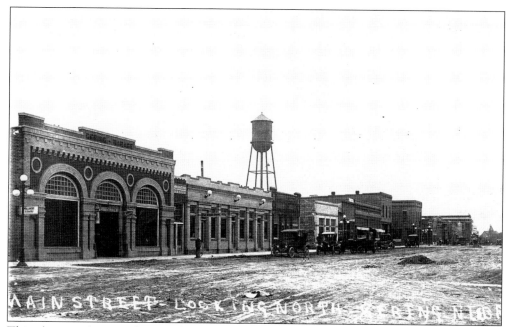

This photograph was taken in the early 1900s. It shows the west side of Gering downtown between M and N Streets. Many of the buildings on this block, such as the old Gering Garage, were architecturally historic and were an integral part of the business history of Gering. The entire block was razed to make room for the new Gering Civic Center.

The Gering Civic Center is located on the corner of M and Tenth Streets. The convention center has contributed a great deal to tourism and attracted business to Gering. The convention center is modern in construction but the interior decor honors the history of the Oregon Trail and the history of Gering.

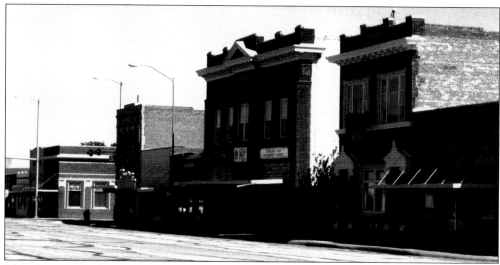

The photograph above shows the east side of Gering's Tenth Street in 2008. One can see that this part of downtown has not been so affected by redevelopment. The pharmacy building was once the stately Gering Hotel but the Courier building, the Fraternity building, and the old Swan Hotel are still much the same as when they were built. At the far left of the photograph is the historic Emery building.

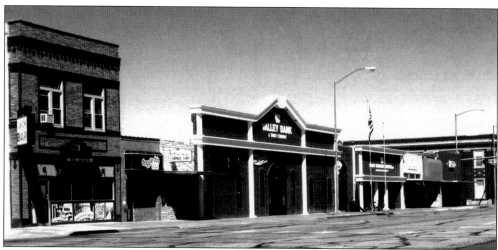

The photograph above shows the west side of Gering's Tenth Street between N and O Streets in 2008. The large building on the left was once the First National Bank building. The Valley Bank building was once the Gering National Bank building and other small businesses. At the other end of the block was the old Gering Mercantile Store, now occupied by Main Street Appliance.

Two

SCOTTSBLUFF

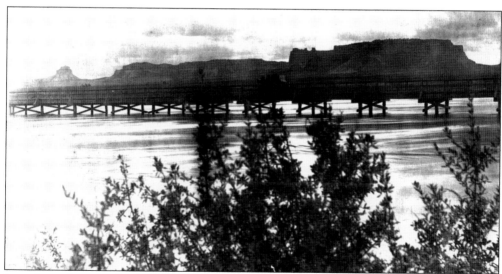

In order to become the Scotts Bluff County seat and gain the support of persons living on the north side of the river, Gering leaders pledged to build a bridge across the North Platte River. Martin Bristol, Gering builder, and Martin Gering, Gering's namesake and banker, were responsible for its completion in 1889. It joined Seventh Street in Gering to the current Fifth Avenue in Scottsbluff. When the Chicago, Burlington and Quincy Railroad arrived on the north side of the river in 1900, the City of Scottsbluff was established.

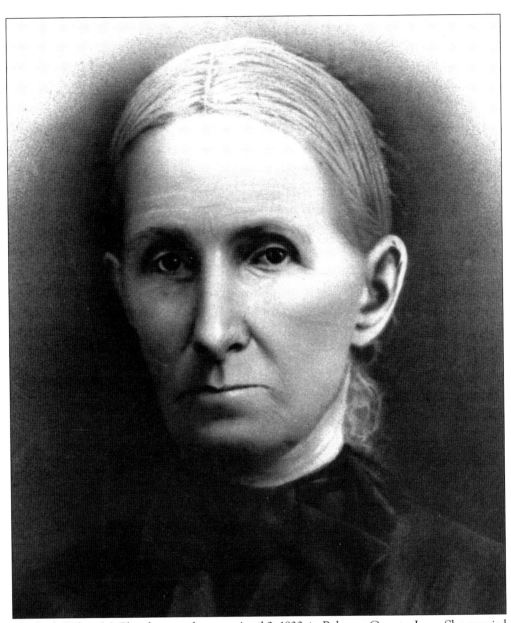

Elizabeth Wilson McClenahan was born on April 2, 1830, in Belmont County, Iowa. She married Elijah McClenahan on May 17, 1855. After he passed away in April 1886, she moved west with 7 of her 11 children and established a tree claim at the present site of Scottsbluff. She was an educated, rugged outdoorsman who endured many hardships and was the epitome of the ideal pioneer woman. In 1899, the Chicago, Burlington and Quincy Railroad wanted to build through the North Platte Valley. Consequently the town site of Scottsbluff was platted by the Lincoln Land Company, a railroad subsidiary, on land purchased from Elizabeth McClenahan. The tracks reached Scottsbluff in February 1900. After the trains arrived, Elizabeth and her family built a small brick house on Fifth Avenue and tore down the old soddy because it was too close to the tracks. Elizabeth and her family all took part in the growth of the newly established town. The brick house on Fifth Avenue is still in use as a home.

John Emery, an early founder, was born in Madison County, Iowa, in 1864. He came to this area before Scottsbluff became a town, persuaded by his brother Frank to move west. John married Amanda McClenahan, daughter of Elizabeth, in 1888. John was a visionary, wanting to build a hotel on Broadway. The Emery Hotel, the first boardinghouse, was destroyed by fire in 1929. John was instrumental in bringing irrigation to the Winter Creek area and was a trustee on the first Scottsbluff Village Board in 1900. Pictured below, in the top left hand corner, is the Emery Hotel in is new location on First Avenue.

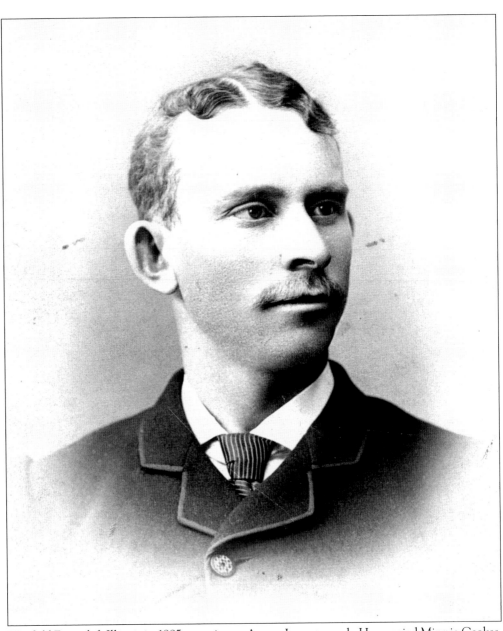

Winfield Evans left Illinois in 1885, stopping at Avoca, Iowa, to work. He married Minnie Coakes, and in 1886, they left in a covered wagon to homestead in western Nebraska near Sunflower Valley, between Mitchell and Scottsbluff. They had two children. Minnie died in 1893 at the age of 25. Winfield married Henrietta Hughes and had four more children. Because of the difficulty in making a living on a homestead, Winfield became Scottsbluff's first building contractor. He and Frank Draper built the first building in 1900, a grocery store and home for Ed Kirkpatrick. Winfield was instrumental in bringing the first "brick" building, the Spry and Soder Saloon, from Gering to Scottsbluff. Winfield served in many elected positions throughout the years and was involved in every aspect of civic organizations. It was said that Winfield never backed down from anyone if he thought he was right. The hard work of Winfield garnered many trophies in 1918 and 1919 for agricultural produce displays at the international expositions and state fairs.

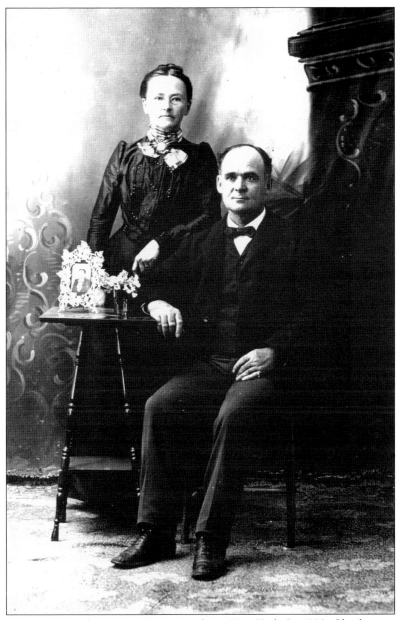

Charles H. Simmons was born in 1858 in Hamilton, New York. In 1880, Charles married Alice Sheldon and had seven children. They left New York and arrived in western Nebraska in 1886, took out a homestead, and lived in a dugout for a short period of time. Then they moved five miles west of Scottsbluff and built a sod home. In 1898, the family moved to Gering and opened a grocery store. In 1900, they moved to Scottsbluff and went into the grocery business again, moving two log houses from Gering and setting them in a cornfield. Charles was appointed postmaster of Scottsbluff and was in that position until 1910. He also served as the justice of the peace. Alice Simmons, a deeply religious person, was active in the building of the Presbyterian church. Charles and six others secured some boards and built a shack to serve as the first church. As long as Alice lived, she continued promoting church work. She died in 1918 and Charles in 1945.

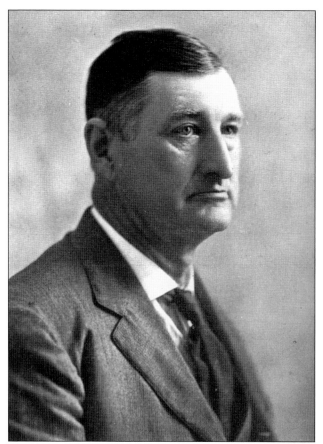

Eugene T. Westervelt, founder, editor, and proprietor of the first newspaper in Scottsbluff, the *Scottsbluff Republican*, was a molder of public opinion and an active public citizen. In 1877, his family homesteaded in Custer County, Nebraska, living in a town called Westerville. In 1886, he married Laura Amos and came to Gering in the 1890s, where he served as Scotts Bluff County sheriff. He then moved to Scottsbluff in 1900. He moved his house from Gering to Sixteenth and Second Avenue. He and Laura had nine children. The photograph below is a blacksmith shop on Avenue A owned by Westervelt's brother, Claude. Claude married Ada Slates on August 12, 1900, at the home of Eugene. They were the first couple to be married in Scottsbluff.

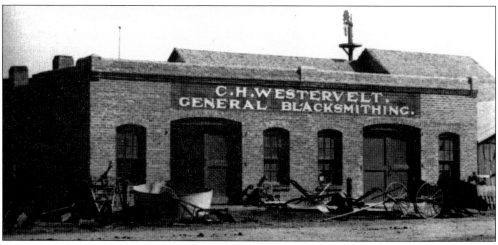

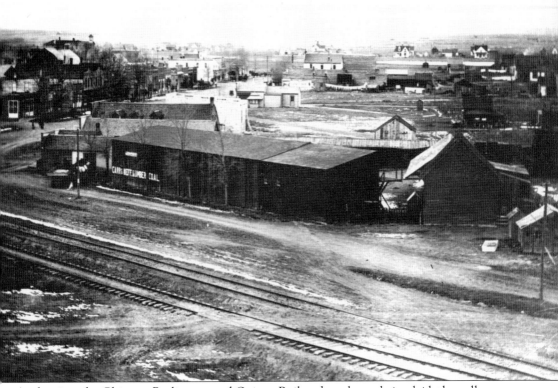

At the time the Chicago, Burlington and Quincy Railroad track was being laid, the valley was already dotted with homesteads, ranches, irrigation ditches, and farms. The "Old West" was still in evidence, and law and order were a factor. Charles S. Simmons was quoted as saying "a holstered 45, hanging tethered to a leg, was not an uncommon sight." It is important to note that one could find false-fronted frame buildings, saloons, cowboys, and gamblers, as in any typical frontier town. After Scottsbluff became a town, a number of existing buildings were moved there from Gering, especially residences. New construction included a grocery store and the Emery Hotel, followed by a post office, feed store, newspaper, restaurant, general store, harness shop, barber shop, photograph wagon, dressmaker's shop, lumberyard, and more. A two-classroom school was built on Avenue A. Growth abounded after the first four years, due to the development of irrigation and the sugar company. Thus a town was born and continues to change with time.

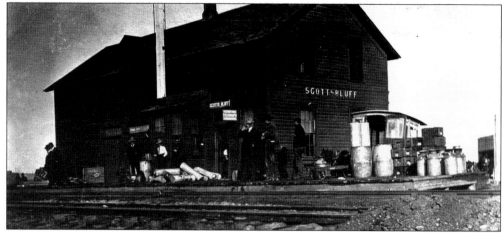

According to Charles S. Simmons, "The B and N Railway placed a discarded box car in the center of, and to the extreme south end of what is now Broadway. They set it smack up to the tracks on a few ties and called it a depot." Very soon, however, a permanent depot was built. The small boxcar beside the depot was used as an icehouse and for beer storage. The photograph below is of the present depot, completed in 1917.

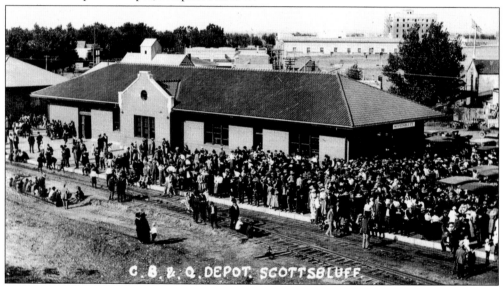

Winfield Evans told the following story about the Armstrong Saloon that was built in 1901. H. C. Armstrong told an African American helper to paint a sign above his saloon. Armstrong was out of town when the man crawled upon the pitched roof and painted *saloon* in letters 12 to 16 feet high. When Armstrong returned and got off of the train, he saw those startlingly huge letters staring at him and began to laugh. He finally convinced the African American man that "saloon" was spelled with two *N*s. The African American man did not argue the matter but climbed back up on the roof and made the sign read "saloonn." The sign was never changed. The saloon was located where the Chiakos Brothers had their tavern across from the depot. The photograph above is the earliest known of Scottsbluff, and the famous "saloonn" can be seen in the picture.

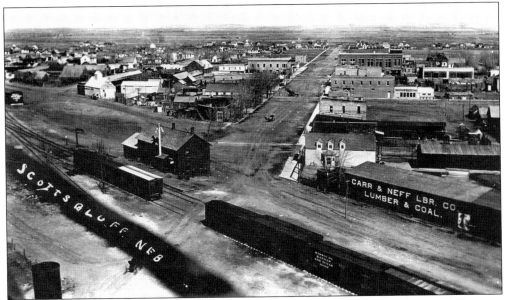

James Carr and Henry Neff started a lumber company in Gering in the early 1900s. However, when the Burlington Railroad arrived in Scottsbluff there in April 1900, they moved their business to take advantage of the convenience of getting lumber from the train. They purchased land near the railroad at Fourteenth Street and Broadway. The Carrs and Trumbulls bought out the Neffs in 1936, but the business name did not change until 1950. The business remained at the Broadway location until it moved to 1310 Circle Drive in 1996. The business continues to be owned and managed by descendents of the Trumbull family. The photograph above shows the 1900 company, and the photograph below shows a later building.

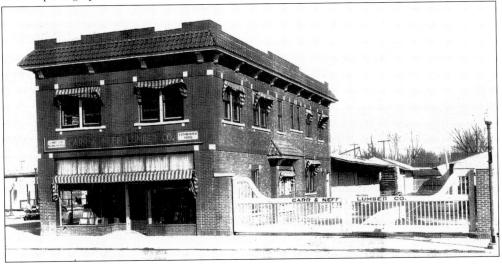

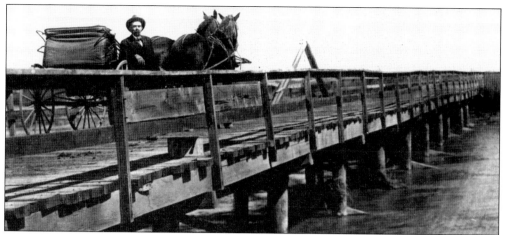

On August 20, 1900, residents voted to use $6,500 to build a bridge (above) across the North Platte River west of Scottsbluff on Twentieth Street (near today's Riverview Golf Course). According to early history, it was needed so homesteaders in Mitchell Valley could cross the river to trade in Scottsbluff. The photograph below is the new bridge on south Broadway built in 1922, connecting Scottsbluff and Gering. This was a much stronger bridge than the east bridge connecting Fifth Avenue to Seventh Street in Gering.

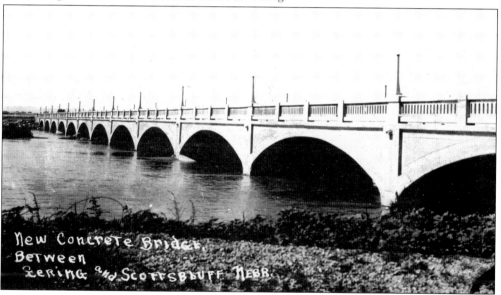

Winfield Evans stated that the first school building was built on land donated by the Lincoln Land Company on Avenue A between Eighteenth and Nineteenth Streets. By the end of 1900, only two rooms were completed. Two more rooms were added on a second level in 1901. The first two teachers were L. L. Raymond and Loretta Trowbridge. Then Agnes Lackey and Minnie Young were added to the staff in 1901. H. J. Wisner said the Scottsbluff School District was organized on April 2, 1900, by county superintendent Perl Stone. He continued to say it was built outside the law without much behind it, except faith that people are honest and will pay their debts without legal authority, knowing the need for a new schoolhouse. It was soon paid for. This 1902 picture is of a class and their teacher in what looks like a special occasion.

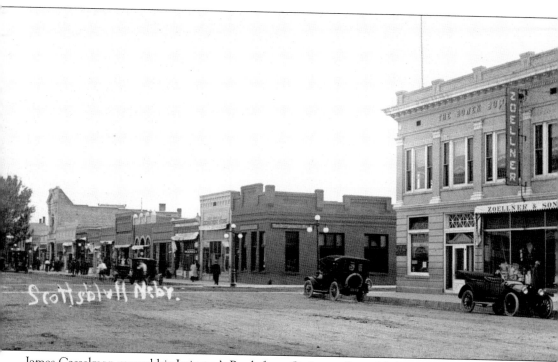

James Casselman moved his Irrigator's Bank from Gering to Scottsbluff early in 1900 to make the town's early beginning complete. The picture shows the bank at the southwest corner of Sixteenth Street and Broadway. Jonas Zoellner came to Scottsbluff in 1905 from Deadwood, South Dakota, to expand his mercantile business in a young town with a population of 1,300. He joined in partnership with his brother and then eventually bought him out in 1908. His only son, Charles, joined the business as a partner. The name was changed to Zoellner and Son as can be seen in the photograph above. Zoellner and Son remained in business until the mid-1980s and was operated by Alan H. Williams, son of Dorothea Zoellner Williams. Zoellner and Son, through the years, carried many well-known brands of men's clothing.

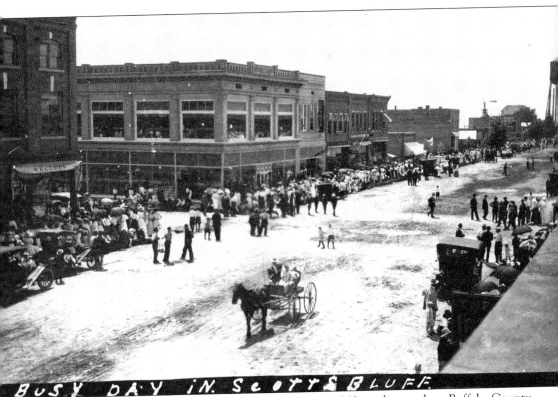

BUSY DAY IN SCOTTSBLUFF.

Frank A. McCreary was born in Ohio on March 23, 1868, and moved to Buffalo County, Nebraska, with his family in 1873, and finally to Scotts Bluff County in 1899. He lived for one year in Gering and ran a general mercantile. He then moved to Scottsbluff and opened a mercantile in partnership with George B. Luft. Later Frank's brother bought out Luft, and the business became McCreary Brothers. The store carried a large inventory and sold a wide variety of items. The brothers also operated an undertaking business. Frank served on the first village board and was mayor of Scottsbluff in 1919. In early 1900, the McCreary store was at the southeast corner of Sixteenth Street and Broadway, and as the business grew, a new building was built. This area later became the heart of Scottsbluff's business district. The building was razed in the 1990s and became an office complex. The above picture appeared in a 1929 issue of the *Scottsbluff Republican* newspaper.

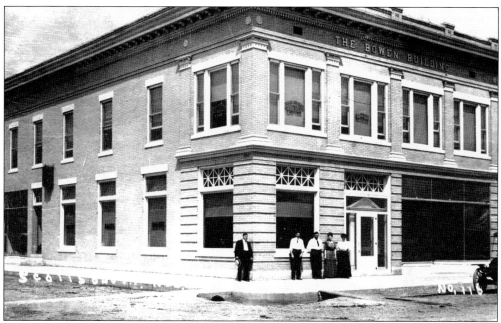

The Bowen Building, built by Andy McClenahan in the early 1900s, was a double two-story building on Sixteenth Street and Broadway. The upper level was used for entertainment, and the main level was the L. Probst Grocery Store and the Park's Brothers General Merchandise Store. Later the main level housed the First National Bank, Zoellner's, and the New York Cash Store. The upstairs held private offices. On the side street toward the back was a dentist's office. The 1940s photograph below shows changes in the Bowen Building. It housed the L. B. Murphy Company and Lawrence Drug. Zoellner's moved down the street. The building was eventually razed to construct the new L. B. Murphy Company, currently Waterbed Showcase.

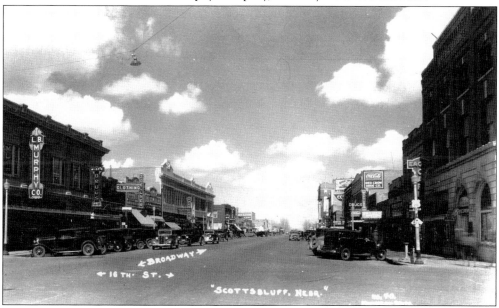

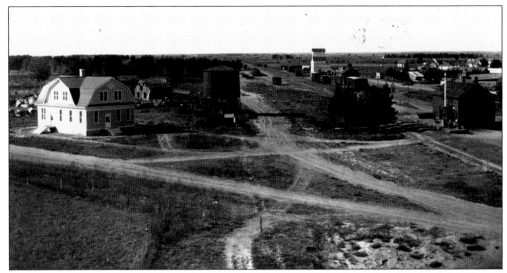

The Tri-State Land Company Headquarters building, located at 13 West Overland Street, was built in 1907. The second floor became the meeting hall for the Independent Order of Odd Fellow (IOOF) lodge and Rebekahs. It is now on the state and National Register of Historic Places. It is currently the office for Herstead Monument Company, purchased in 2001 after the Scottsbluff centennial.

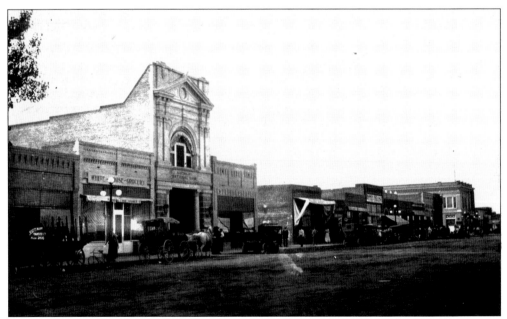

This 1909 street scene shows the hustle and bustle of the new town. Scottsbluff National Bank (center) was built by the Ostenberg family on the west side of Broadway. The bank later moved to a new location on the corner of Seventeenth Street and Broadway. Hank Kosman, Harvey Ostenberg's son-in-law, succeeded him as president. The bank continued in the Kosman family with Hank's son Hod as president. Hod remained with the bank under several owners, until he established Platte Valley Companies in 1996.

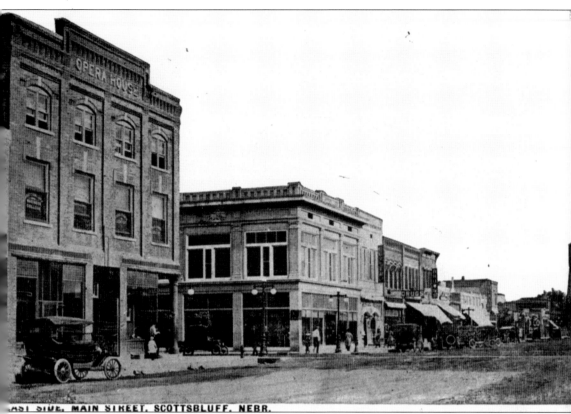

EAST SIDE, MAIN STREET, SCOTTSBLUFF, NEBR.

The Marquis Opera House was built by Lewis Marquis in 1909, at Sixteenth Street and Broadway, at the end of an era of traveling road shows. During the six years of its existence, a variety of events were held there including professional performances, commencement exercises, church bazaars, firemen's balls, political speeches, professional dancers, vaudeville acts, and dramas by local groups. It closed in February 1915 due to lack of interest and support from the community. It was also affected by the opening of the Star Movie Theater that featured similar activities. Eventually the building was purchased by Wade Flynn, whose name remains on the building today. Nebraska Securities Company occupied the building for many years. Tallmon's Jewelry purchased it in 1970. The following is a quote from Florence Dyer's thesis in 1987: "From the remnants that remain, it appears to have been lavish for such a new city. Scottsbluff's Marquis Opera House remains as a fine example of the end of one era in the world of theatre and the social base of a new era in a young town in the West."

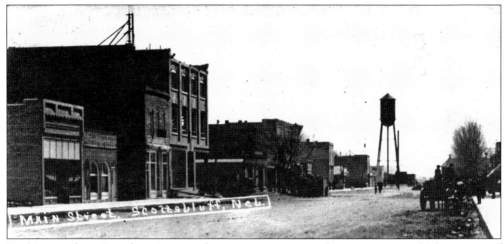

Looking south on Broadway in an early street scene, notice the water tower, which was one of the earliest structures in Scottsbluff. Many photographs and aerial views in this book were taken by Otis W. Simmons, a photographer and contractor. Simmons would climb to the top of the water tower to get magnificent shots. His brother Charles S. Simmons began his work with sign painting in the early 1900s and then extended into artistic painting, with his pictures being very much in demand. The photograph below shows the brothers, Otis (left) and Charles S., sons of Charles H. and Alice Simmons.

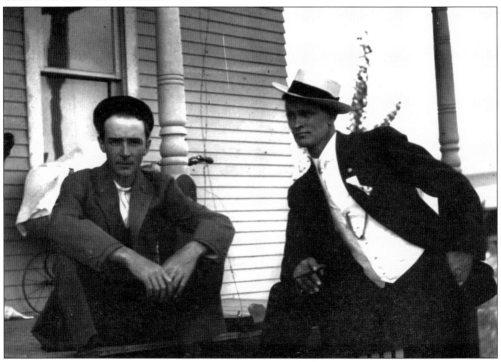

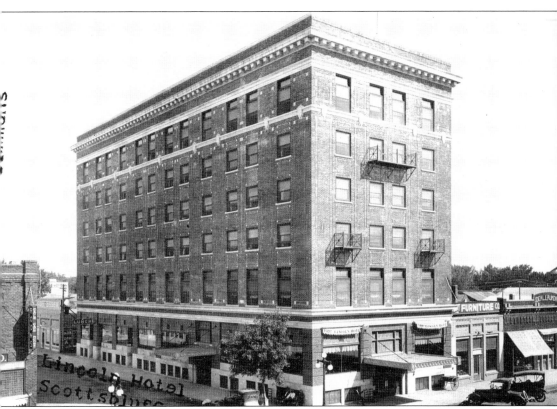

The Lincoln Hotel, built at the southeast corner of Fifteenth Street and Broadway, had its grand opening on December 31, 1918. At the time, it was the only fireproof hotel in Nebraska and one of the largest, with over 100 elegantly furnished rooms with private bathrooms. It had an excellent dining room, and on the sixth floor, a large ballroom used for conventions, meetings, and private parties. For the traveling man, the Lincoln Hotel was the "next thing to home—a great place to stay," according to the *Scottsbluff Republican* of June 28, 1929. In 1965, the hotel was purchased by Hiram Scott College, remodeled, and used to accommodate students as a dormitory and classrooms until 1971. From 1976 to 1983, it was again used as a dormitory by Platte Valley Bible College. In 1998, the building was listed on the National Register of Historic Places. Early in the first decade of the 21st century, it was again remodeled as individual apartments for subsidized senior housing. In the photograph, the Ideal Laundry can be seen two doors down from the hotel.

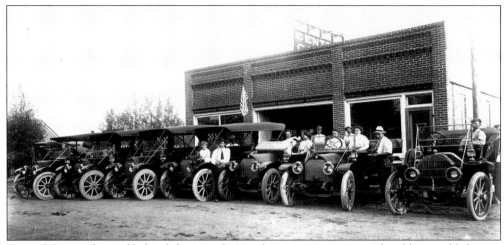

Central Garage, located behind the Lincoln Hotel on First Avenue was the oldest establishment of its kind in Scottsbluff. It opened in 1911 and was operated by A. T. Crawford as the Crawford Garage. Shown above is the original building plus the two additions built to accommodate the growth of the business. Together A. T. and his wife Blanche (Jones) Crawford operated a successful business.

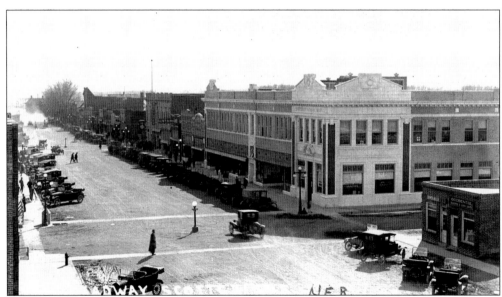

The large Fliesbach Department Store is located next to the new Scottsbluff National Bank. It was the largest business in early Scottsbluff and was the largest department store in Scotts Bluff County. Harry and Chester Fliesbach, from Imperial, Nebraska, opened the store in 1910 or 1911. They followed in the footsteps of their father, who had owned a department store in Imperial for 20 years, before selling out and moving to Denver. At first their store featured dry goods, but they added several departments including men's and women's apparel and a millenary on the top floor. It closed in the late 1920s. F. W. Woolworth Company and J. C. Penney's later occupied the building. Note the light posts in the middle of the intersections.

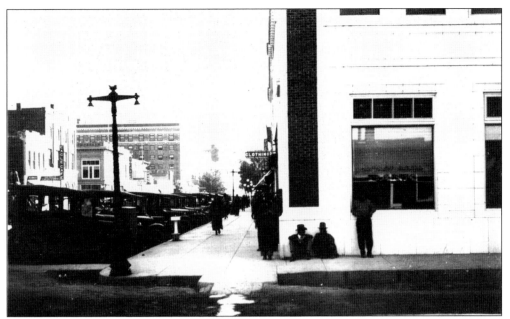

This street photograph was taken on the corner of Seventeenth Street and Broadway in about 1921. Scottsbluff National Bank is the building on the right side of the picture. Notice the unique lamppost and the water fountain along the sidewalk. Also of interest are the older gentlemen who would gather next to the bank to share the news of the day. On the opposite side of the street is the Eagle Cafe.

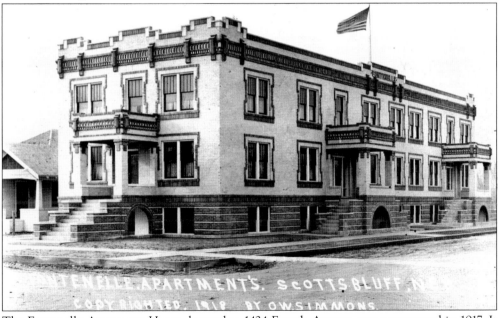

The Fontenelle Apartment House, located at 1424 Fourth Avenue, was constructed in 1917. It originally contained 12 apartments with a series of double entries, built to suit individual owners. A 1917 article in the *Scottsbluff Star-Herald* stated, "the Fontenelle is practically finished, and is without question one of the 'handsomest' structures of the city." It is now on the National Register of Historic Places.

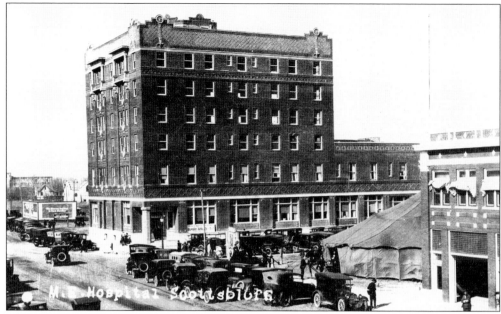

The Methodist Hospital was originally built as a hotel but was never completed because of bankruptcy. After much negotiation, it opened as the Methodist Episcopal Hospital in April 1924 with 20 beds. A school of nursing was added in 1925. Its name changed to West Nebraska Methodist Hospital in 1928 and West Nebraska General Hospital in 1954. In 1967, it moved to its new building at the present site of Regional West Medical Center on Forty-second Street and Avenue B.

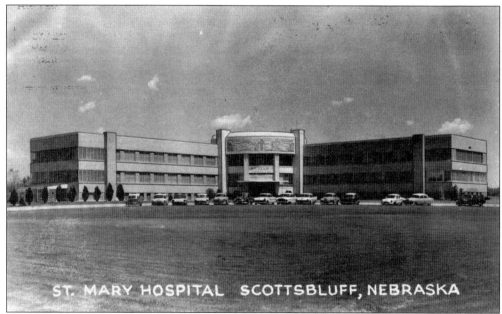

The sisters of St. Francis once operated the Fair Acres Hospital located on West Twenty-fourth Street, but outgrew the facility. Groundbreaking for the new St. Mary's Hospital was May 31, 1947, and it opened as a 104-bed facility on September 12, 1949. In 1977, St. Mary's Hospital was purchased by West Nebraska General Hospital for $1.5 million.

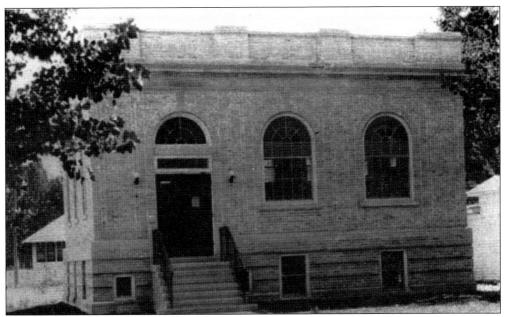

The Carnegie Library (above) was constructed at Eighteenth Street and First Avenue in 1922, with an addition in 1936. The picture below features six book worms reading in the basement of the library. Many young people researched for their senior paper on the top floor. A $135,000 bond issue was approved for the construction of a new library to be located at East Eighteenth Street and Fourth Avenue. It opened in 1966. The old Carnegie Library became West Nebraska Art Center.

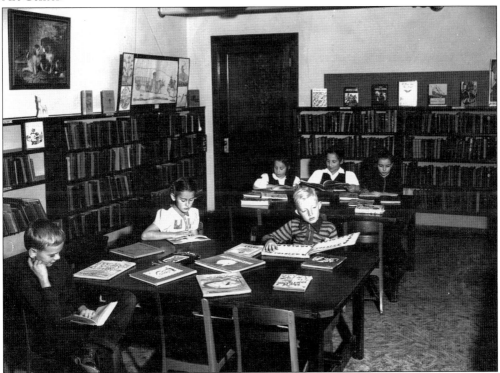

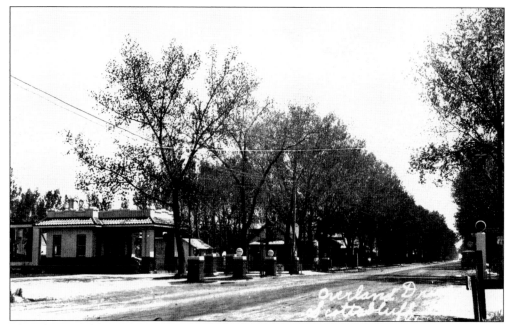

This photograph at 201 East Overland Drive was taken about 1928 and shows the Mead Oil Company Gas Station as seen through a high-powered photographic lens. Several different signs are visible, including one advertising gasoline for 19.9¢ a gallon, a gasoline station sign across the street, and a Highway 26 sign. John and Earl Mead were involved in the oil and feed business for many years with John's son Dick taking over later.

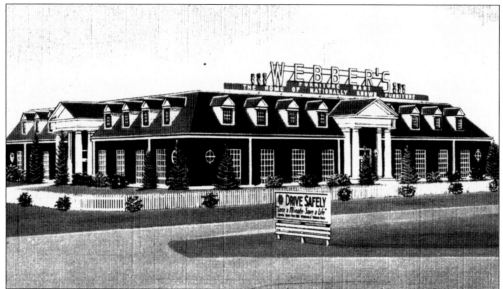

Webber's Furniture Company was founded in 1929 by Jack and Mayme Webber. It was located on the north side of Sixteenth Street, before moving to the present location at Twenty-seventh Street and Broadway in 1940. It was advertised as the world's largest retail furniture store and was designed to look like the College of William and Mary. This building burned to the ground in 1950. The business was rebuilt in 1960 by Lee and Dorothea Smith. Current owners are John and Karen Smith.

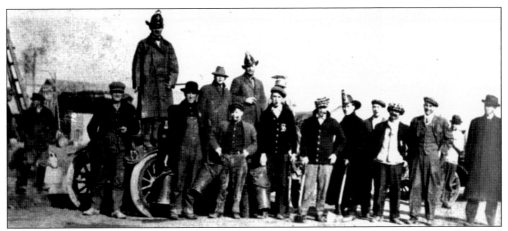

The photograph above is of the 1920s Scottsbluff Fireman's Bucket Brigade. The buckets and helmets were their uniforms and equipment. As stated in the Scottsbluff centennial book *Coming Home to Scottsbluff—The First One Hundred Years*, "A passerby discovered a fire at the jail and ran to the Presbyterian Church where he rang the church bell to summon the Scottsbluff Bucket Brigade. The wooden structure was destroyed. Montgomery was burned to a crisp." The cause of the fire was not immediately known but was later determined to be fireworks lit by an inebriated inmate named Montgomery. The photograph below is of the Scottsbluff Fire and Police Patrol, also from the 1920s. Two gentlemen in the image can be identified: John Orr, a plumber (first row, center), and H. J. Wisner, a journalist (second row, right). Notice they are now using hoses instead of buckets in their firefighting efforts.

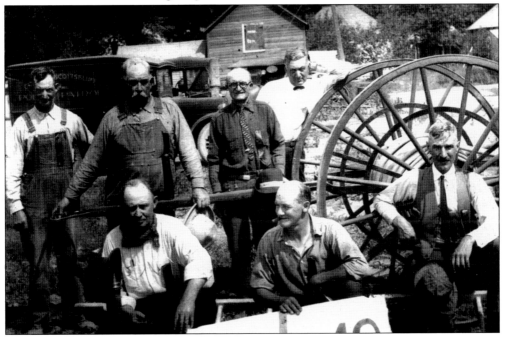

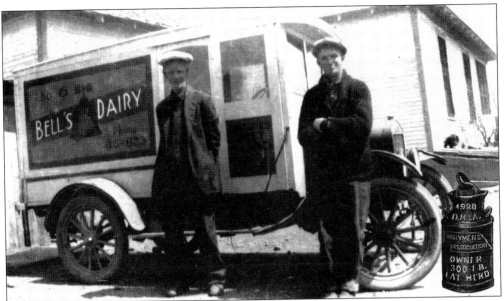

Charles and Kate Bell moved to Scottsbluff in 1918 to start a dairy business. They began with one cow and soon increased their herd to 30. Along with the milk production, they raised chickens, sold eggs, and grew vegetables to sell on their "truck" farm on East Overland. Above are Charles and his son George. The dairy won an award in 1928 from the Dairy Herd Improvement Association.

The Idlewild Dairy, also known as Maxwell's Dairy, began as a stock farm in 1925 according to Charles Maxwell, son of Melvin and Rena. Melvin and his parents, Benjamin and Rose, started the business on the north side of East Twenty-seventh Street near the Highway 26 bypass. In 1952, the Beatrice Food Company purchased the business, which became the Meadowgold Dairy.

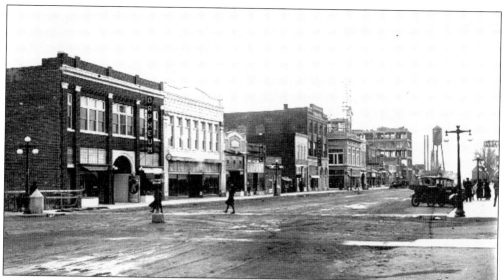

In January 1919, William H. Ostenberg purchased the Orpheum Theater pictured above on the left. It was opened in the early 1920s and stayed in business until the early 1940s when it became known as the Bluffs Theater.

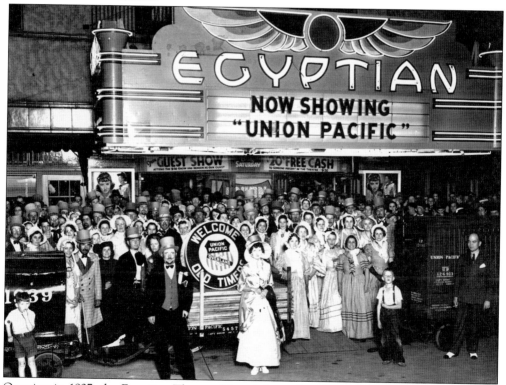

Opening in 1927, the Egyptian Theater (above), located at 1701 Broadway, was the dream of Ostenberg. It had a seating capacity of 1,111 and was equipped with a specially designed organ that had a volume of 160-piece symphonic orchestra. For its time, it was considered a very "grand" theater. In 1945, it was consumed by fire. The Egyptian Theater was replaced by the Midwest Theater.

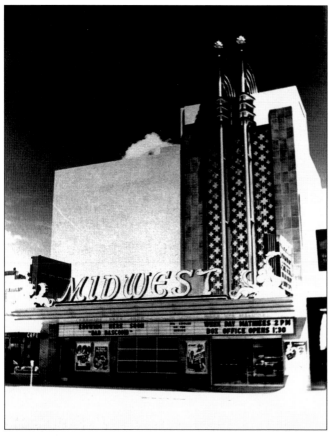

The Midwest Theater opened May 3, 1946, with much fanfare. The theater's most striking feature is the marquee with a stainless steel and aluminum tower extending 60 feet above the entrance. The interior of the auditorium was just as spectacular, with neon, floral scrolls, murals, and a futuristic sound system. The theater has been renovated due to the efforts of the volunteer group, Friends of the Midwest, and is now on the National Register of Historic Places. The photograph at left is the Midwest Theater in the late 1940s, and the photograph below is inside the theater, showing children watching a movie. Thanks to the Friends of the Midwest, movies and performing arts can still be enjoyed at the Midwest.

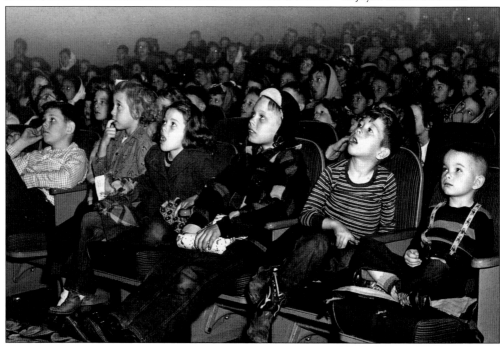

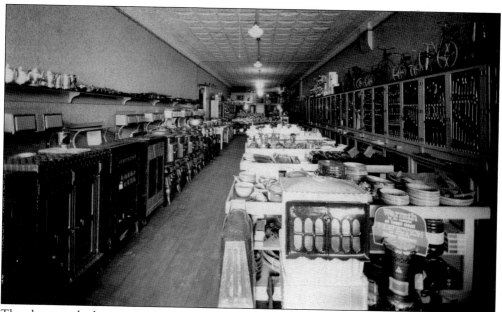

The photograph above was taken inside Standard Hardware at 1521 Broadway in the late 1920s. It was the successor to McCreary Brothers Hardware Company, managed by William McCreary. In about 1947, the business was purchased by Wayne and Frances Towner and moved to 1813 Broadway. The photograph below shows the raising of the Standard Hardware sign, being placed at the new location. The business flourished, having a multitude of different departments, selling everything from nuts and bolts to large appliances. In the 1960s, it became known as Ace Hardware.

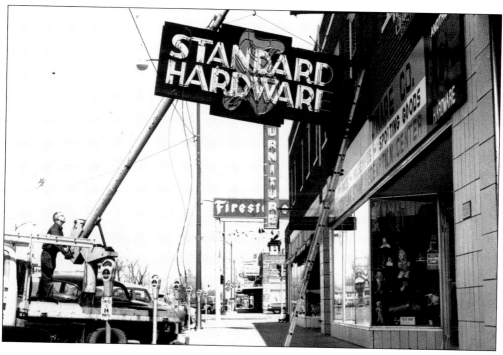

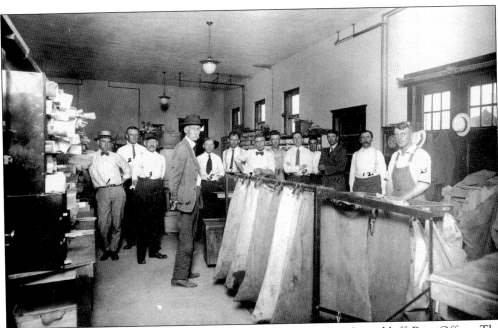

Mail carriers (above) get ready for a busy workday at the first Scottsbluff Post Office. The photograph below is the post office, completed in 1931. Though the building was designed in the Roaring Twenties, the end result seems to have been altered, perhaps by the stock market crash and the Depression that followed. The original drawings show the building to be much larger with plans for a third floor. The second floor, which wraps around a large open space, was designed to have a large room to be used by the federal court; however, politics caused the court to be relocated to North Platte. In 1988, John Baker submitted a bid to purchase the building for an office complex. The building was remodeled and is now on the National Register of Historic Places.

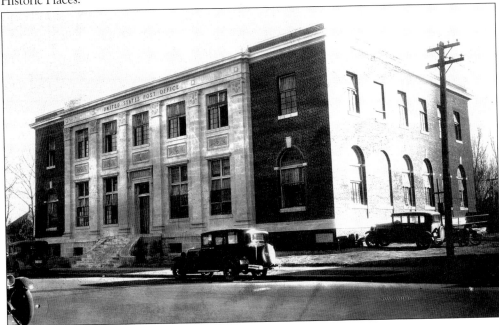

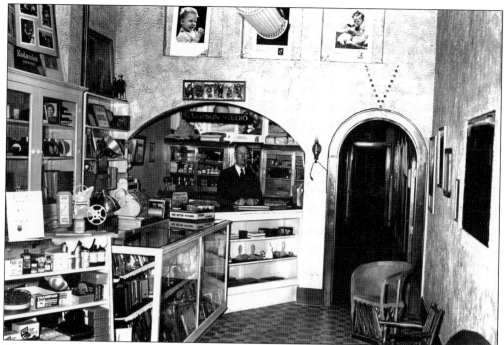

Severson Studio, located at 1719 Broadway, opened in 1917. The owners were Herbert (above) and Edna Severson. At one time, they operated three photographic studios, one in Bridgeport, Torrington, and Scottsbluff. In 1945, the name changed to Severson and Son when Milton (nicknamed "Buss") joined his parents. According to Kim Severson, Buss's son, Edna was a bit ahead of her time, in that she worked at the store and also colored black and white photographs.

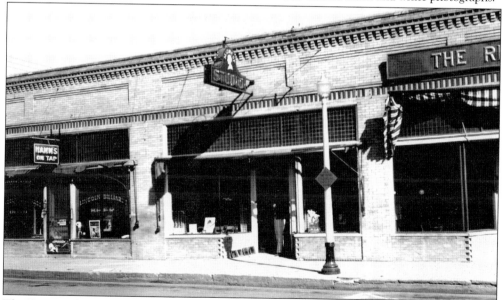

The Downey family came to Scottsbluff in 1934 and opened Downey's Midwest Studio at 17 East Sixteenth Street. In the picture, one can see negatives lined up by the doorway, in the sunlight, to become brown proofs. The business is still operated by the Downey family. The building that housed the *Scottsbluff Republican* newspaper can be seen to the right in the photograph.

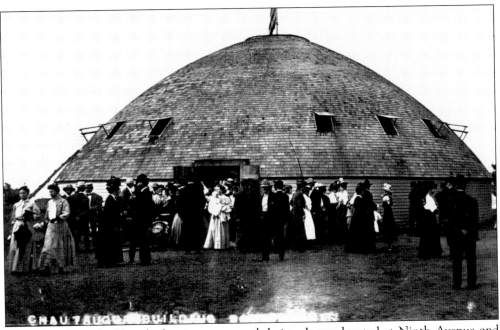

The Chautauqua building had quite an unusual design. It was located at Ninth Avenue and East Overland Drive, where Roosevelt School is today. It was in existence between 1905 and 1911. The Chautauquas featured entertainment, guest speakers, religious training, and political speeches. During meetings, people rented tents to camp on the grounds until the season was over. Notice the air vents on the roof and the attire of the period.

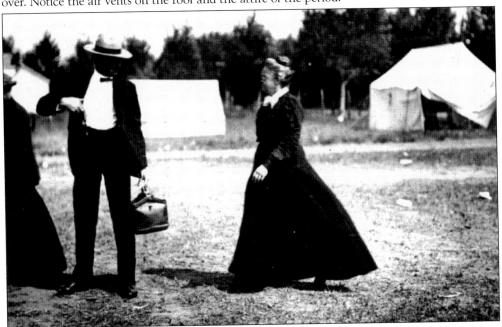

Harvey Sams offers assistance to Carrie Nation, who arrived to speak at the Scottsbluff Chautauqua. Nation headed the women's temperance movement, traveling and speaking on the "evils of liquor." Sams was an early pioneer, active in civic and educational programs. He was instrumental in establishing the Scottsbluff library and his home still exists on East Overland Drive.

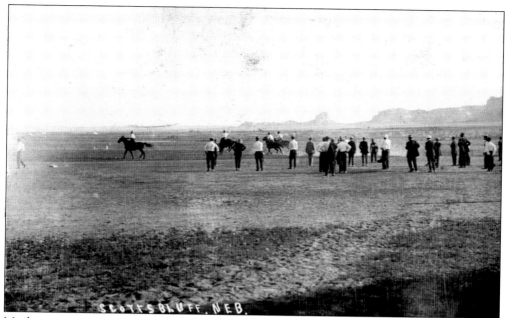

Much entertainment in the early 1900s was self-made, such as basket suppers, dances, horse races, shooting matches, ball games, county fairs, Memorial Day and Fourth of July parades, band concerts, rodeos, drum corps, and Saturday nights with their unpredictable adventures. There were individual parties, Sunday church, ice skating, swimming in the North Platte River, hay rides, hikes to the monument, card games, and probably somewhere, a lover's lane. Sadly funerals were also a time for social gatherings. The picture above depicts a 1900s rodeo, held in the open range with Scotts Bluff National Monument in the distance. The photograph below is of a Fourth of July parade in the early 1900s. The images bring to mind the Charles Simmons quote "As for entertainment, t'was a sorry soul that found no chance to laugh or be amused in every day's living."

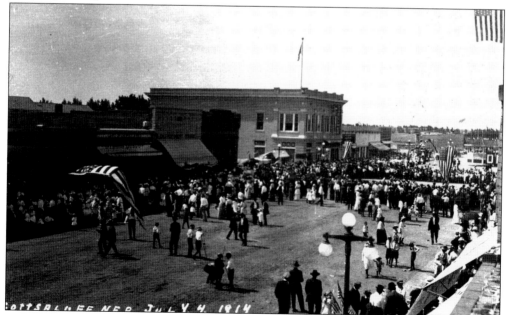

In 1921, L. L. Cawley decided to go into business for himself and started processing horseradish and honey. In 1926, he ordered a potato chip cooker and produced potato chips in his garage. Eight 100-pound bags of potatoes could be cooked in a 12-hour day. In 1932, the facility was enlarged, and in 1950, a new cooker was added, allowing 60 100-pound bags of potatoes to be cooked in a 12-hour day. The business was called Cawley's Tater Flakes, Inc. In years to follow, delivery trucks and other snack foods expanded the business. Cawley's Tater Flakes closed after six decades in business in 1983. Many school-age children remember touring the factory and sampling chips.

Chief Inksplasher:
Paul Holten
Chief Setterupper
Mrs. B Messman
Adchaser
"Jim" Subbert

HORSE-HIDE CORNER

Gazette

TELEPHONE 963X

EAST OVERLAND SCOTTSBLUFF NEBRASKA

Pictured above, from the early 1950s, is the top half of an advertising flyer, the *Gazette*. Humorous stories, advertisements, and classified advertisements were included in the *Gazette*. It was published by "folks at the Horse Hide Corner" at a location on East Overland Drive. Floyd Bigger began to occupy the corner of East Overland Drive and Twenty-first Street in 1933. Bigger's first building was a 12-by-20-foot gasoline station with two pumps. Additional pumps were later added, as was a short-lived lumber business in 1939. Bigger's other enterprises included a car auction that brought people from 10 states and later, a farm equipment auction. Bigger's "pink colored" drive-in theater (below) was the second of its kind in the state. Completing the corner was Bernice Bigger's ceramics shop, which included a school for teaching the art of ceramics.

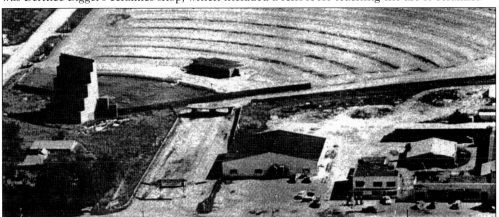

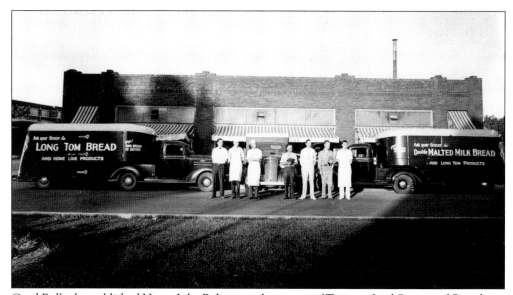

Cecil Bullock established Home Like Bakery on the corner of Twenty-third Street and Broadway. The bakery marketed home-like products and featured "Long Tom Bread." Note the sign on the delivery truck reading, "Double Malted Milk Bread." In the late 1930s, Fritz and Frieda Micklich purchased this bakery business, and it became Dutch Maid Bakery.

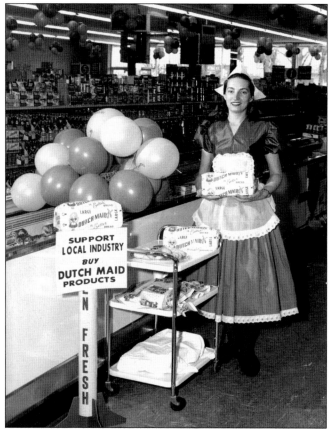

Donna (Micklich) Hackman, seen above dressed as a Dutch maiden, promotes Dutch Maid Bakery products at a local grocery store. Dutch Maid Bakery remained in business until the late 1950s. Later the building was used as a bowling alley, restaurant, and credit bureau.

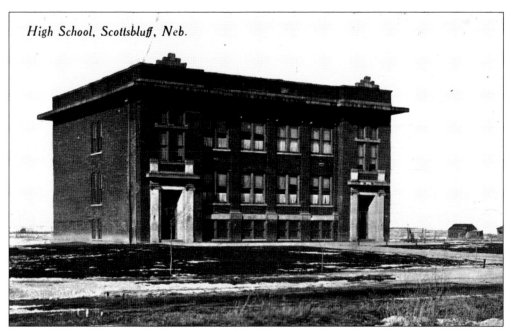

High School, Scottsbluff, Neb.

Central Ward School was built at a cost of $27,000 and was located on the corner of Twentieth Street and Fifth Avenue. This school was the second school built in the Scottsbluff district between 1913 and 1915. At that time, it served as the high school. Through the years, it was also used as a grade school, the Scottsbluff Junior College. Centennial Park now occupies the entire block and is used for many community events.

East Ward Public School, Scottsbluff, Neb

Little is known about East Ward School. It was probably built after 1911 when the Chautauqua building was razed. The Roosevelt School is now located on the same site, at the corner of East Overland Drive and Ninth Avenue.

Bryant School was built at 511 West Fourteenth Street in 1921 and used through the late 1970s. Today the building is used by Community Christian, as a private Christian School.

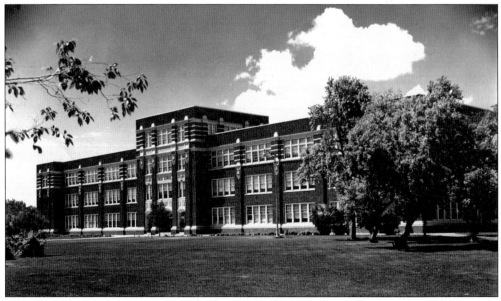

Scottsbluff High School, at Twenty-third Street and Broadway, was built in 1924 for $280,000. The annex, as it was called, was added in 1950. It remained a high school and junior high until 1961 when a new high school was built on East Twenty-seventh Street. It then became Scottsbluff Middle School and remains so today.

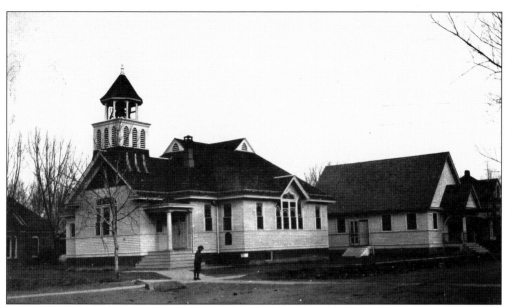

The first church in Scottsbluff was the Presbyterian Church built in April 1900. Charles H. Simmons and six others secured some boards and built a shack at Sixteenth Street and First Avenue. Seats were boxes and plank pews. The new Presbyterian Church (above) was erected on the same location in 1903. The present Presbyterian Church at First Avenue and Twentieth Street opened for services in 1925.

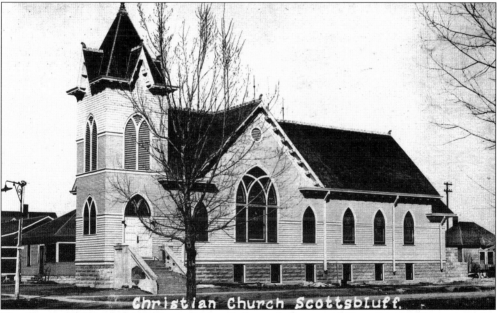

The Christian Church was built in 1901 at Eighteenth Street and First Avenue. For a time, the Methodists, Presbyterians, Episcopalians, and Lutherans used this church while their new ones were being built. The Methodist church met there the longest, and when a payment came due on the building, the Methodist ladies helped hold a bake sale to raise money. This could be considered as the first ecumenical affair in Scottsbluff. The new building at 2201 Avenue A was built in 1955.

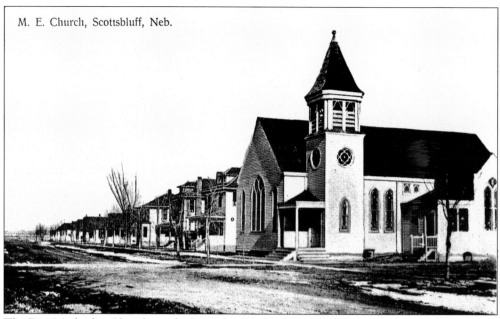

M. E. Church, Scottsbluff, Neb.

The First Methodist Church was built on the corner of Sixteenth Street and Second Avenue in 1907 at a cost of $7,000. Before the church was built, services were held at West Ward School. In 1920, an auditorium seating over 1,000 people was constructed. It was used as a school gymnasium during the week, and as a place for religious gatherings at other times. The new church at Twentieth Street and Fourth Avenue was dedicated in 1946.

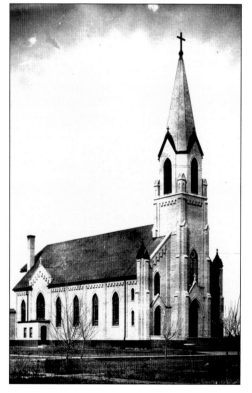

The first small Catholic church, St. John's was built in 1903 at Seventeenth Street and First Avenue and was used as a mission church. In 1912, Fr. T. J. O'Bryne built St. Agnes Catholic Church at its present location at 2314 Third Avenue. St. Agnes Grade School was added at a later date. Other early churches were St. James Lutheran, Episcopal, German Lutheran, and Plymouth Congregational.

The earliest known record of Hightower Grocery at 901 Ninth Avenue is in the 1933 business directory at North Platte Valley Museum. The owner was R. E. Hightower. His poultry farm at 1403 Fifth Avenue was also listed in the directory. The store continued to be in business until the late 1970s or early 1980s.

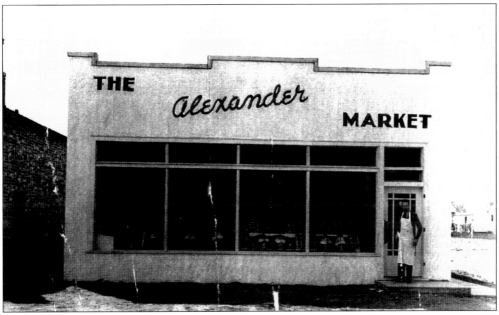

Alexander Meyer stands proudly in front of his new market at 1114 East Overland Drive in the early 1940s. As a young man, Meyer worked in the grocery business with his father in a small neighborhood in east Scottsbluff. In November 1955, Meyer and his family celebrated the grand opening of their new store at the northwest corner of Twenty-first Avenue and East Overland Drive.

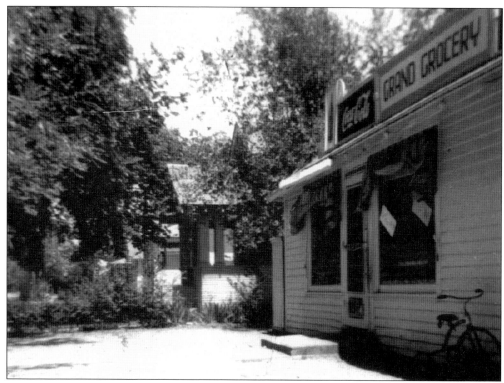

The Henderson Market had its beginning on Ninth Avenue in 1922. According to Sandy Cook, her father, Dale Henderson, came back to Scottsbluff to help his mother run the Ninth Avenue store after her husband passed away. He was 21 years old. In 1941, Dale and his wife, Catherine, purchased the Grand Grocery on Fourth Avenue. For a while, both stores were in business at the same time.

In 1940, Otis Terhune built the building for Bob's Superette on Avenue I and West Overland Drive. It was rented by Bob Krueger, and a few years later, he purchased it. In 1968, Doug and Jean Tuttle purchased the store and continued operations under the name of Bob's Superette. It was torn down in 1986 and replaced with a gasoline station and Quick Shop.

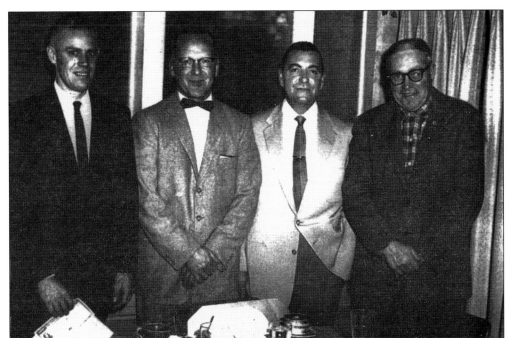

Jerry Buehler and Harold Reading moved with their families to Scottsbluff from Utah in 1944 to work for O. P. Skaggs Grocery Store. About 1947 or 1948, Martha Hillerege, mother of Terry Carpenter, had a building constructed for them at Avenue D and Twenty-seventh Street. They opened Terry's Town and Country Market. Pictured above, from left to right, are Norm Engleman (manager), Harold Reading, Jerry Buehler, and Terry Carpenter. At right, Harley Behm and Norm Engleman are talking with some special customers inside the store. A popular feature in the store was the soda fountain. In 1958, Terry's Town and Country Market moved to Twenty-seventh Street and Avenue B, to a new, larger store built by Jack and Mayme Webber.

Pictured above is the 1955 Saddleaires Drill Team from the Panhandle Saddle Club. There were 24 members with Virginia Cassells as drill mistress. Cassells was well known for her expertise in showing, jumping, and trick riding. In the image below, Ishmael (Ish) Schmidt announces at one of the Panhandle Saddle Club's horse shows, and Marie Smith, treasurer and assistant secretary, assists. The organization hosted many horse shows with various classes, including jumpers, gated, fine harness horses, and parade. Ish was an "institution" in the community as an announcer, storyteller, and master of ceremonies and was a stranger to no one.

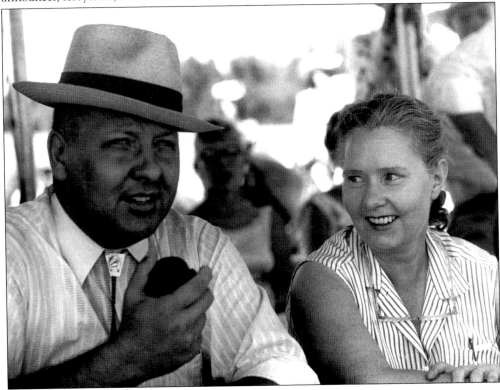

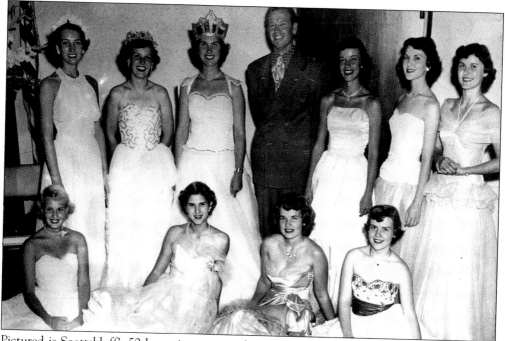

Pictured is Scottsbluff's 50th anniversary royalty. They are, from left to right, (first row) Joan (Croswell) Hyde; Lucy (Lawrence) Van Duin; Dorothy (Elliot) Massey; and Susan (Rheinhardt) Bailey; (second row) Donna (Micklich) Hackman and Ruth (Raymond) Thone, attendants; Demaris (Riddel) Bradley, queen; Rex Allen, cowboy movie star; Marilyn (Parrish) Reavis; Esther (Schwartzkopf) Siegel; and Ramona (Van Wyngarden) Downey.

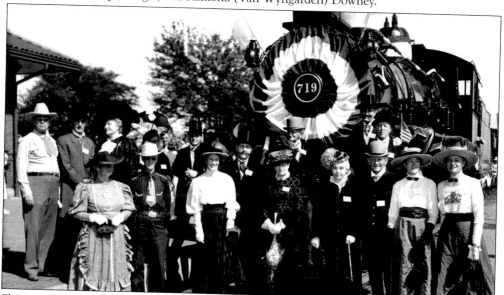

Shown is a replica of the first Chicago, Burlington and Quincy Railroad train that arrived in Scottsbluff in 1900. The train, as part of the 50th anniversary celebration, was scheduled to arrive in Scottsbluff at 2:00 p.m. on Sunday, August 6, 1950. In the foreground are prominent citizens taking part in the 50th anniversary celebration. The celebration, also known as the Golden Jubilee, was celebrated with many other activities, such as a parade and a children's play.

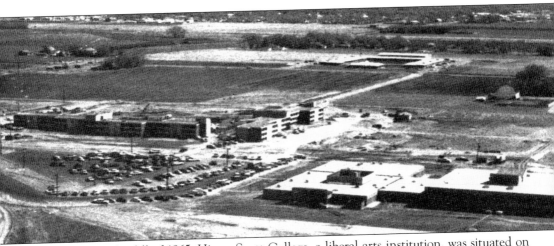

Established in the fall of 1965, Hiram Scott College, a liberal arts institution, was situated on a 440-acre sugar beet field on the north edge of Scottsbluff. The college was the inspiration of several businessmen and community leaders who recognized that a four-year college would be a huge economic and cultural advantage for the Nebraska panhandle. The college was modeled after Parsons College in Fairfield, Iowa, a post-secondary institution managed like a business in a profitable manner. Hiram Scott peaked in its fourth year, having 1,500 students from all over the United States, a library, several completed buildings, and the government promise of finances. Except for the lack of endowment funds and the end of the Vietnam War, the concept of a college run for profit may have succeeded. The school closed in the summer of 1971. Several students remained in the area building homes, businesses, and taking part in civic activities. The current site is now occupied by the University Panhandle Station.

Three

TERRYTOWN

Histories of small towns or villages usually contain an intriguing chapter or two assigning their creation to a defining event, situation, or person. The city of Terrytown, being no different, owes its beginnings, part and parcel, to one dynamic, unforgettable person, Terrence (Terry) McGovern Carpenter (1900–1978). Praised as "defender of the little man" by some and reviled as a selfish opportunist by others, Terry went about introducing new concepts and building a business empire. He was an entrepreneur, developer, politician, and visionary.

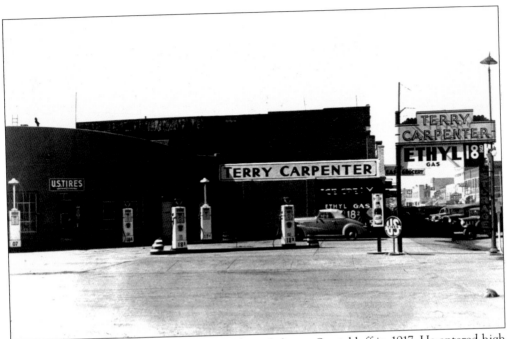

Terry Carpenter moved with his mother and stepfather to Scottsbluff in 1917. He entered high school but left school after three weeks, ending his formal education. In 1929, after a brief stint in California city government, Terry returned to Scottsbluff and operated a filling station located at East Overland Drive and First Avenue. Terry blamed big oil companies for high gasoline prices, and his lowered prices started a gasoline war.

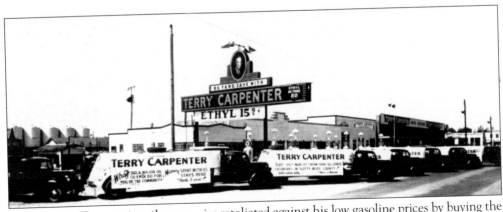

According to Terry, major oil companies retaliated against his low gasoline prices by buying the land his gas station occupied and evicting him. He bought land just south of the Scottsbluff railroad tracks and began to build his business empire.

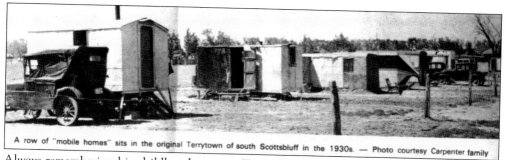

A row of "mobile homes" sits in the original Terrytown of south Scottsbluff in the 1930s. — Photo courtesy Carpenter family

Always remembering his childhood poverty, Terry allowed mobile homes to be parked on his property during the 1930s. Many people were penniless during this time and camped on Terry's land in buggies and wagons. The disparaging term "Terrytown" was applied to the area, but Terry jumped on the name and began to promote his string of businesses as Terrytown. In 1937, Terry attempted to incorporate the "settlement" and his businesses into Terrytown. His concept was to establish a town with as little government as possible, but his proposal was turned down by the county commissioners. In reference to Terry's controversial political and business careers, he was dubbed "Terrible Terry," and once again capitalized on a derogatory term.

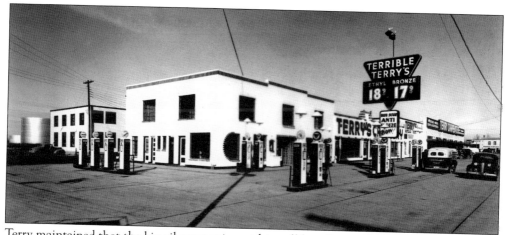

Terry maintained that the big oil companies cut him off from his supplier, so he built a railroad spur and a simple refining operation. He had crude oil shipped from Wyoming. As his operation grew, his refinery supplied gasoline for his Terrible Terry's chain locations in Nebraska, Colorado, and Wyoming.

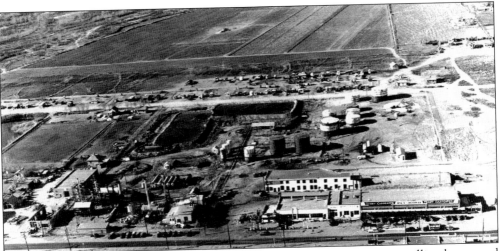

To bring business into the filling stations, Terry Carpenter built a creamery, selling butter and ice cream along with gasoline. In order to promote himself as he ran for elected offices, he also established a newspaper, the *Daily Senator*, which published for close to a year. Terry's image appeared on packaging for most of his products.

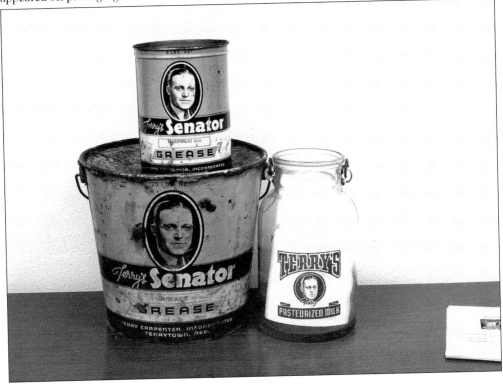

Terry's sprawling business complex included a bottling plant (above), a flower shop (below), grocery store, offices, and trucking line. Terry sold his business property to Consumers Cooperative in 1941. According to Terry, stress from the sale caused him to go blind for a brief period of time. Thereafter he entered the U.S. Army Air Corps and rose to the rank of major.

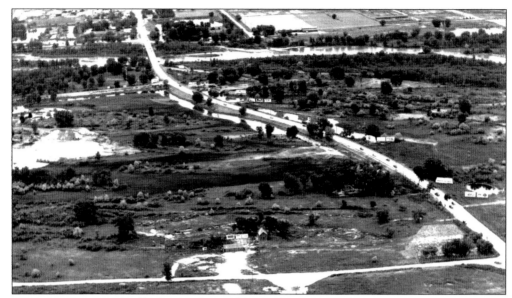

Returning to Scottsbluff after an honorable discharge from the military, Terry Carpenter purchased a large tract of swampland just south of the North Platte River, which included a gravel pit (above). He soon added a block, brick, and concrete business. In 1948, he filled the swamp and began building apartments and houses. Terrytown, with its own electrical and water systems, was soon incorporated as a village. Over time, a laundry, radio station, gasoline station, riding stable, general store, park, trailer court, fine dining establishment, drive-in theater, and one of the largest arenas in the state (all owned by Terry) were added to the village. He sold much of the frontage property on the highway. The picture below, taken in the 1950s, depicts Terrytown's diverse establishments including the riding stable, visible in the far right of the photograph.

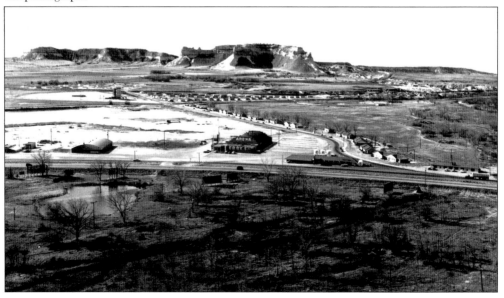

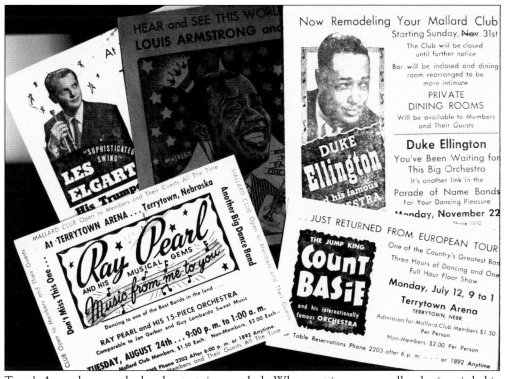

Terry's Arena became the local entertainment hub. When not in use as a roller skating rink, big name performers packed the house. In the late 1960s, the arena was converted into a self-service grocery store. The building also housed a popular eatery, the Copper Kettle. In July 1968, a fire, believed to have been ignited by fireworks, destroyed the structure, except for the Terrytown jail located at the rear. The jail remains standing and is currently used for storage.

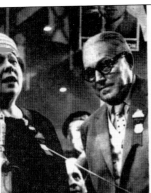

Terry Carpenter was a political maverick. His political career spanned more than 40 years. He ran for mayor of Scottsbluff, the House of Representatives, served in the Nebraska Unicameral for 18 years, ran for Senate five times, made a run for governor of Nebraska, and regularly switched parties. His most notorious act occurred when he was a delegate to the 1956 Republican National Convention. Angry at what he perceived as a closed election process with no chance for "citizen input," Terry nominated fictional "Joe Smith" for vice-president, shocking delegates ready to rubber stamp an Eisenhower-Nixon ticket. After making the nomination, he was escorted from the convention by guards. "I'm not in a position to explain why Joe Smith became a reality . . . (he was) just a symbol of a free convention," he said. The national press focused attention on Terry Carpenter of Nebraska. Reporters from Maine to California ran the story. Several authentic "Joe Smiths" from across the nation contacted Terry and offered to be "the" vice presidential nominee. At home, reaction to his antics ranged from anger to delight.

Coming full circle, Terrytown became home to one of the first low-income housing developments in the area. The complex, built in the late 1960s, lies to the south of Terry's park and lake.

Hazeldeane Carpenter donated the Carena Drive-In and surrounding land to the Scotts Bluff County Housing Authority in 1993, with the stipulation that the site be developed as a recreational/educational facility for low-income persons. Classrooms for alternative school and early learning, a gymnasium, fitness room, and Terrytown city offices (Terrytown attained city status in 2005) are housed in the facility. Ball fields, a park, and walking path lie adjacent to the building.

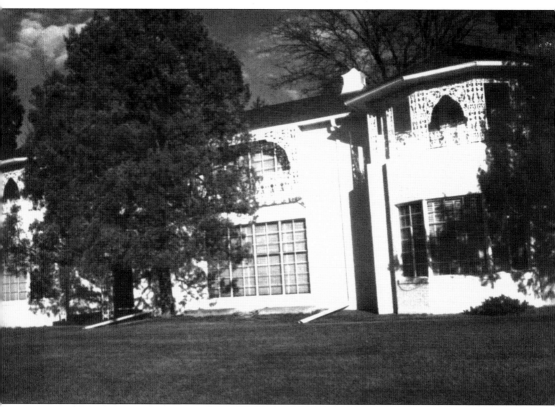

The Carpenter home, located at 2309 Third Avenue in Scottsbluff, was built by Terry and Hazeldeane Carpenter in 1939 and remains a city landmark. After Terry's death in 1978 and that of Hazeldeane in 2001, many of their personal belongings, along with some of the household decor, were auctioned by Sotheby's. Terry was a powerful figure in Nebraska politics. Always quotable, he was a master of the one liner. "Politics is a dirty, double-crossing business. That's why I like it," he once jibed. After his election to the House of Representatives in 1933 he said, "All the way to Washington I wondered what I was doing there. Then after I got there, I wondered how the hell did these guys get here?" When questioned about his genuine concern for the common person he quipped, "Sure I want to help these people. Come the revolution, they'll go right for the biggest house in town—and I live there." And most appropriately, he stated, "Take the press out of here and I'll shut up."

Four

AGRICULTURE

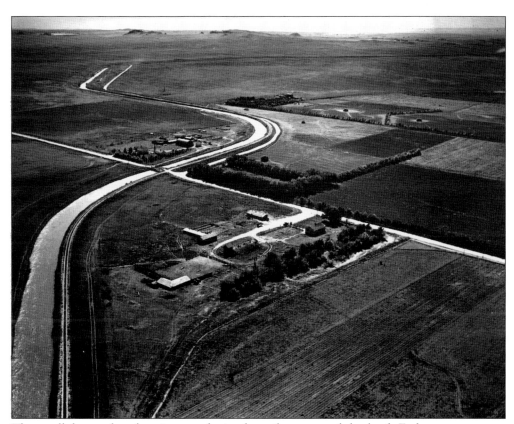

The small farmer found various results in the soil content of the land. Early prospects were promising, but the summer winds baked the ground so hard that it was almost impossible to cultivate, as nothing would grow in the valley unless the soil was irrigated. By the early 1900s, canals brought water to the farms. The farmers felt more secure in their endeavors when Lake Minatare and Lake Alice were set up as reservoirs to be used as irrigation water.

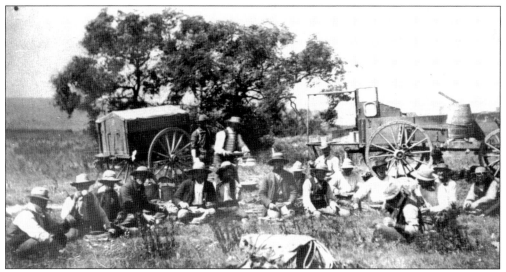

Previous to homesteading, the great cattle companies ranged their herds over Colorado, Wyoming, and the Nebraska Panhandle. The cattlemen formed the Wyoming Stockgrowers. In 1884, the area was divided into 30 sections. Gering was in the area that extended from Camp Clarke to Fort Laramie. The roundups were to start May 20 and October 1. This picture shows a group that participated in the last general roundup in 1887.

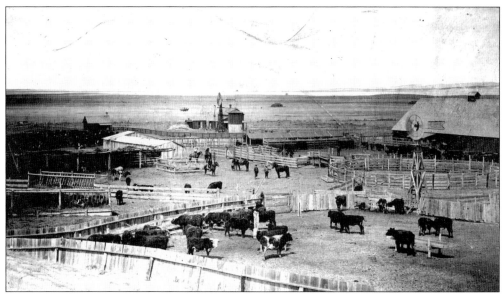

This photograph depicts Frank Beers Ranch around 1900. Prior to this time, huge ranches owned by the Ogallala Cattle Company, Bay State, and others covered the area. By 1887, there were enough settlers in the area to pass the herd law, which made cattlemen responsible for damage to crops. This was the beginning of the "granger" cattlemen, homesteaders who lived on their land but ran cattle on government land.

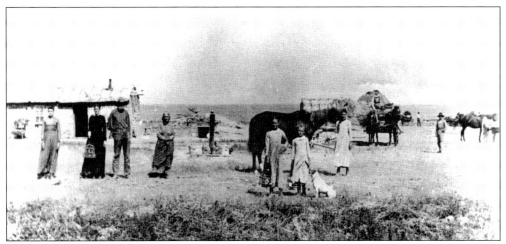

Conventional building materials were not readily available in the Nebraska Panhandle. Sod, or "Nebraska Marble," was the choice of most of the settlers. Not only was it free, but abundant in the area. Due to the thickness of the sod blocks that were used, the homes were relatively comfortable, being easily heated in the winter and cool in the summer. Most of these structures have returned to their original state, found only by the difference in the prairie grasses and the presence of sunflowers in unexpected places.

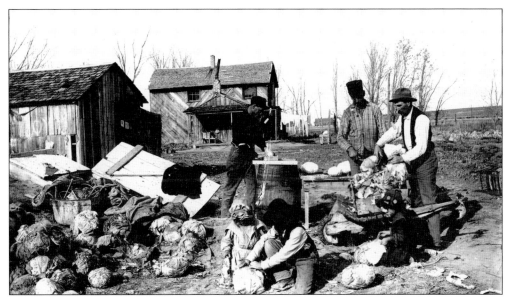

Fortunate was the woman who had an underground cellar for the storage of the produce from her garden, which she had canned or dried. Kraut making was a labor-intensive job in which the whole family could participate during the harvesting and shredding of the cabbage in preparation for its fermentation and subsequent canning.

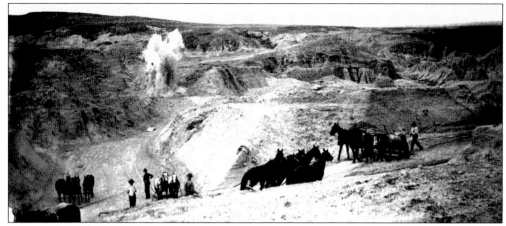

Perhaps the earliest irrigation was utilized by the large cattle companies for their hay lands. The early ditches were dug by homesteaders who put in an incredible amount of hard work and very little money. The picture above, dated April 26, 1898, shows blasting in the badlands and men at work with the teams of horses and mules. In 1889, the Irrigation Law was passed. Around this time the Minatare and Farmers' Canals were completed. In 1902, the Reclamation Act made possible the Pathfinder Canal, completed in 1915, bringing water from Wyoming along the north side of the river. In 1927, on the south side of the river, the Gering-Fort Laramie Canal was finished. In August 1902, the Gering Canal brought the first irrigation water into Gering along the south side of what is now O Street.

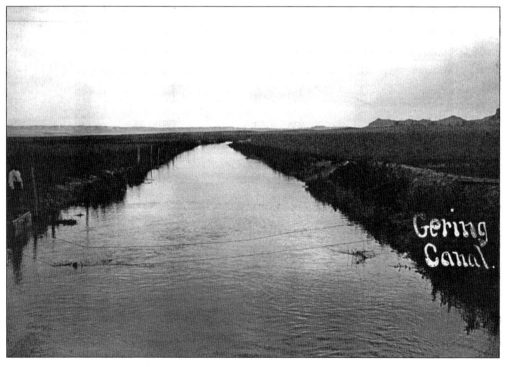

Even though much of the water came from Wyoming through the canals, other water was pumped from the ground. The first water went into the canals and was used in ditch irrigation. Exhaustive manual labor was needed to make sure no area was flooded and that all plants received the water they needed. Irrigation made it possible to grow many more crops such as potatoes, sugar beets, corn, and dry edible beans. Wheat, barley, and oats were grown as a cash crop or feed for livestock. At one time, truck farming was quite popular, using irrigation to grow onions, cabbage, green beans, peas, and other vegetables. The water made possible more cuttings of alfalfa, which was used as livestock feed. Years later some large sprinkler systems were installed, making irrigation easier.

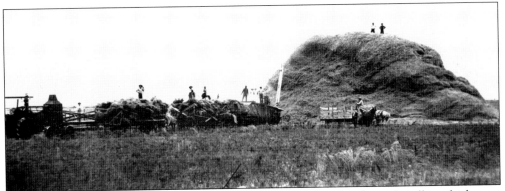

When the grain became ripe, it was cut close to the ground and tied into bundles, which were later shocked, grain side up, in a teepeelike shape. The harvest crew, consisting of several neighbors, would move from farm to farm to thresh the grain. The bundles of grain were pitched by hand onto wagons and then hauled to the thresher where they were pitched into the thresher, separating the grain and the straw.

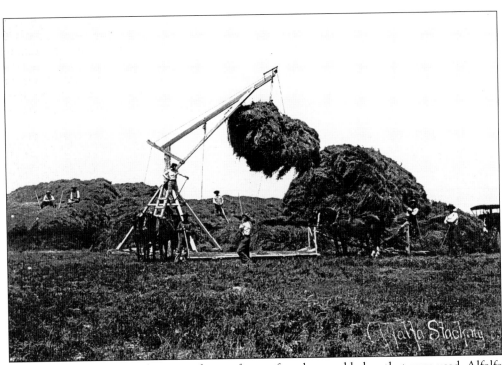

Shown here is a swing stacker, one of many forms of stackers and balers that were used. Alfalfa and native grasses were cut with mowers and raked into windrows. Making a stack was laborious. After the hay was put on the stack, the men would tromp it down and arrange it with pitchforks so it was relatively flat. When the desired height was reached, they would round the top to keep moisture out.

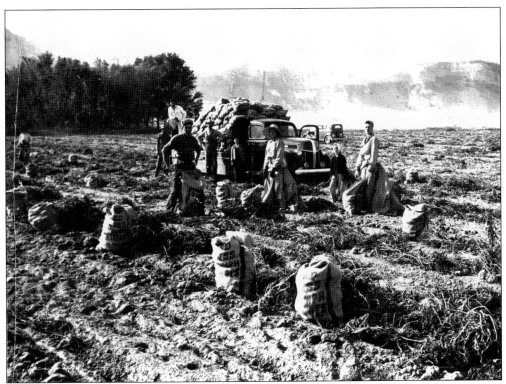

The valley was also suitable to the growing of potatoes, a staple of the American diet. Beginning in the late 1800s, potatoes were grown as a cash crop by many farmers, and evolved into a large industry. More than 60 varieties of potatoes were grown. Many workers were needed for the harvesting, sorting, and processing. During this time, the potatoes were dug, cleaned (not washed), sorted, put into gunny sacks, and then stored in one of the many potato cellars similar to this one before being shipped out by railroad and trucks.

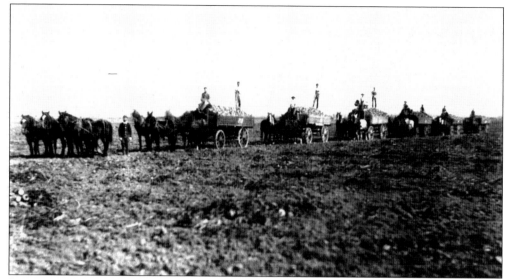

In 1902, Otto Jurgens raised a few sugar beets in his garden and then sent the sample to the Standard Beet Sugar Company in Ames, Nebraska. In 1905, a few local farmers planted about 100 acres of beets under irrigation. By 1909, about 3,000 acres were produced. The following year, Great Western Sugar Company purchased the Ames Sugar Factory and moved it to Scottsbluff. Locally, 9,373 acres of beets were grown. The beet acreage increased steadily, and in 1916, a factory was erected in Gering. Over the next few years, four more factories were erected in the area. In 1928, the six factories put out 2.5 million 100-pound bags of sugar. The by-products were used to fatten cattle and sheep. There are many steps involved in producing sugar (shown below). This is the third stage white pan boiler. Many farmers were employed during the sugar campaign. The Scottsbluff factory is still in operation.

Dry edible beans were an especially suitable crop for the uncertain weather and soils of the area. Several beaneries sprang up as a result of the 40 varieties of beans raised. The dried beans were sorted and packaged for worldwide distribution.

The valley was an ideal site to build a canning factory because of the wide variety of fruits and vegetables grown here. Begun in the late 1930s, the farmers could bring their contracted produce to the factory to be canned and shipped to other areas. The factory employed more than 200 people year around.

The unending chores of the farm were shared by all of the family members in all kinds of weather. Women not only had household duties such as keeping the house, rearing the children, cooking, and preserving foods, but they also had such chores as carrying water from a stream or well for household use. After the water was put to several uses around the house, they then had to carry it outside and empty it—probably on the garden. Women also spent time outdoors feeding the chickens, gathering the eggs, slopping the hogs, and milking the cows. Often money made from the sale of eggs and milk products was used for groceries. Not only did they tend the gardens, they canned and dried foods for later use. Many women worked as field hands with the men, and they were still responsible for their household chores.

Much of the labor on the farms was done by the children. Often there was no one to care for them, especially when the women did field work, so they were taken to the field or wherever the work was being done. Here children were assigned tasks that they were able to do. It was advantageous to have a large family because "many hands make light work."

Apples and cherries, along with other fruits, were grown in small orchards on many of the farms. Women and children were mainly responsible for harvesting and preserving the fruit. The canned and dried fruits provided variety as well as added nutrition to winter meals. Some farmers grew fruit for the local cannery in the 1930s and 1940s.

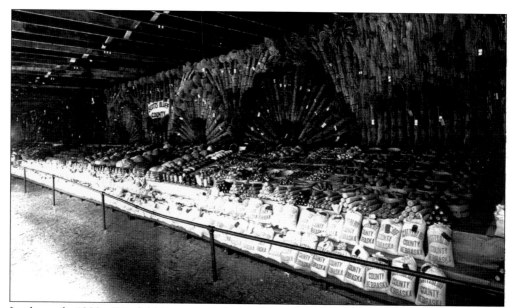

In the early 1900s, Winfield Evans and A. M. Pattison were in charge of the county exhibit. They took to the state fair a sample of practically everything that was raised in Scotts Bluff County—62 varieties of potatoes, 40 kinds of beans, 45 varieties of corn, and the like. In addition to the sweepstakes, the county won a total of 172 prizes. The 1918 display was taken to the Kansas City International Exhibit where it competed with six other states and two Canadian provinces. The exhibit gave the nation "genuine surprise" by winning the trophy (seen below) for "First Award by International Soil Products Exposition Kansas City 1918 by a county." Not only did they win with grains and vegetables, but also won "Best county collective exhibit of fruit." The painting below by Charles Simmons was used for many years with the county exhibits.

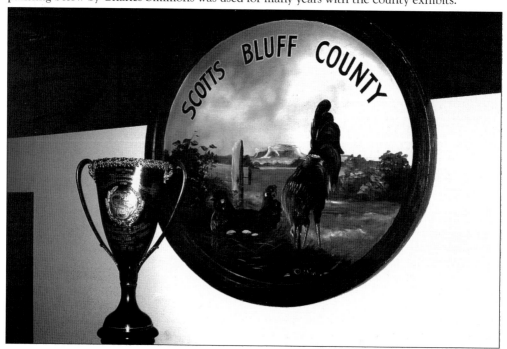

Five

AREA LANDMARKS

Gering, Scottsbluff, and Terrytown are situated in one of the most historically significant and unique sites of the entire westward migration. Trappers, freight wagons, and the Oregon-California, Mormon, and Pony Express trails passed through, as did the telegraph and railroad. The North Platte River supplied life-giving water to emigrants and their livestock as it had for the buffalo and Native Americans who had long inhabited the land. The river, often described as being a mile wide and a foot deep, posed a hazard at crossings, with swift currents and quicksand. Even so, the North Platte Valley offered unique vistas to weary pioneers, just as it does for travelers today. This picture captures the Oregon-California Trail through Mitchell Gap (or Pass), which after 1851 became favored over the longer Robidoux Pass route.

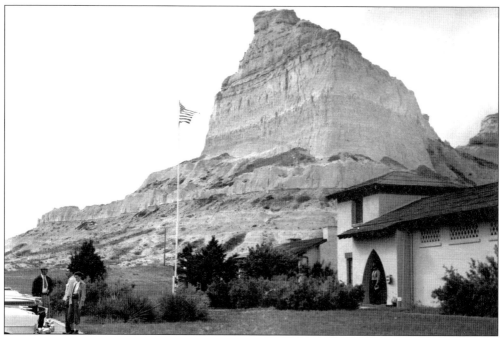

Constructed from adobe blocks by the Civil Conservation Corps in the 1930s, the visitor center for the Scotts Bluff National Monument (above) is situated directly east of Eagle Rock. The visitor center houses the William Henry Jackson Gallery and contains one of the most important collections of original Jackson paintings, sketches, and photographs in existence. Jackson, a member of the 1866 Hayden survey team, camped near the west base of Eagle Rock in that year. Jackson was present at the 1930s dedication of the visitors center. Below is Jackson's rendition of Fort Mitchell, located west of Mitchell Pass on the bank of the North Platte River. The fort was constructed of adobe in 1864 as an outpost for Fort Laramie and operated until 1867.

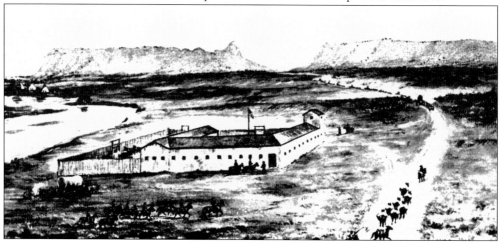

Built by the Civil Conservation Corps, the concrete road to the summit of Scotts Bluff National Monument passes through three tunnels. The summit road opened in 1937, reaches an elevation of 4,650 feet, and provides breathtaking views of Gering, Scottsbluff, Terrytown, the North Platte River, and the surrounding valley. Occasional rock slides hamper both the road and the hiking trail to the summit.

The lighthouse at Lake Minatare is one of only seven inland lighthouses in the United States. Some 55 feet tall, the structure was built in 1937 by the Veterans Conservation Corps (VCC) and consists of native stone. Lake Minatare itself was built in 1915 by the Bureau of Reclamation as a storage facility for irrigation water. Today the lake, lighthouse, and nearby campground create an exceptional recreation experience.

In 1852, Rebecca Winters traveled with her family on the Mormon Trail. After caring for several members of her party who became ill with cholera, Rebecca succumbed to the disease and was buried along the trail. Her grave was marked with a wagon rim etched with the message "Rebecca Winters, aged 50 years." Her grieving family continued to the Great Salt Lake. In 1996, due to the proximity of her grave to the Burlington-Santa Fe tracks, her remains were moved to the site of a marker placed in her honor.

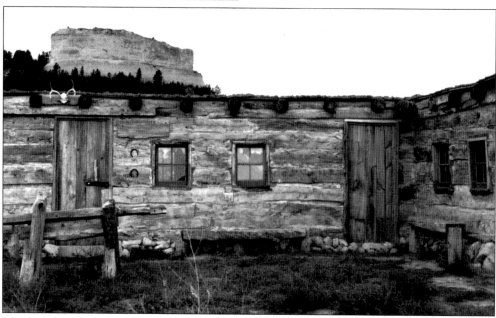

The first recorded entrepreneurs in the area were members of the Robidoux family, who operated a blacksmith shop and trading post along the emigrant trail. Initially located directly along the Oregon-California Trail, the post was later moved further south into scenic Carter Canyon. There is no known description of the first Robidoux post, but pictured above is a replica of the second trading post, rebuilt according to sketches drawn by passing emigrants.

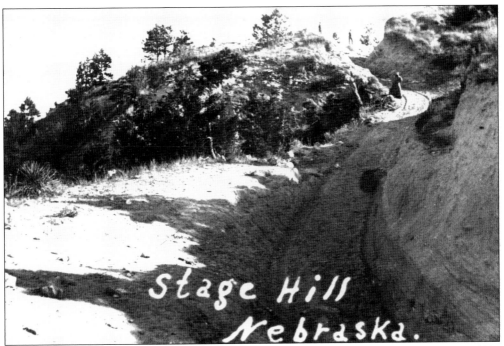

Stage Hill
Nebraska.

The Wildcat Hills shelter the North Platte Valley on Gering's southern border. The only timber available to emigrants and early homesteaders was the ample supply of ponderosa pine located on the higher elevation of these hills. Stage Hill, shown in both photographs, was the treacherous, winding road connecting Gering and Scottsbluff with their neighbors on the southern side of the mountain range. Freight wagons used this road, as did the stagecoach, carrying the all-important mail. Stage Hill was widened and paved before being abandoned when a new highway was completed. Excavation for the new highway yielded an important treasure trove of fossil discoveries to paleontologists and archaeologists.

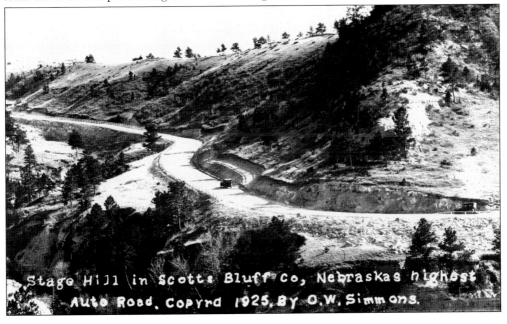

Stage Hill in Scotts Bluff Co, Nebraskas highest Auto Road. Copyrd 1925, By O.W. Simmons.

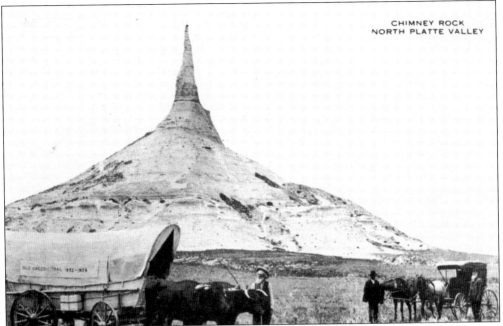

Quoted often in emigrant diaries are descriptions of Chimney Rock. Located 20 miles to the east of Gering-Scottsbluff near the town of Bayard, Nebraska, this "Sentinel of the Plains" remains an imposing site. Erosion and lightning have whittled away at its height, but Chimney Rock continues to be a recognizable landmark. Above, Oregon Trail promoter Ezra Meeker is shown in front of Chimney Rock on his famous 1906 backwards Oregon Trail trek across the plains. Below is Chimney Rock as it appears today.

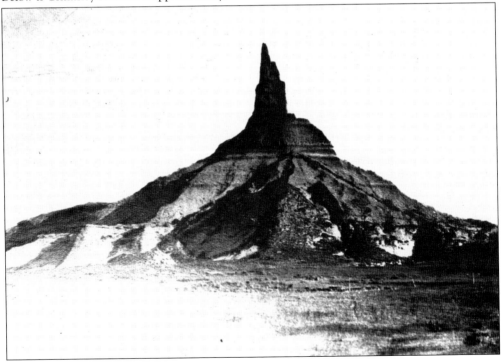

The North Platte Valley Historical Association formed in October 1961 and began collecting artifacts and paper documents. The organization incorporated in 1969 opened the North Platte Valley Museum on Tenth street in Gering. The museum quickly outgrew the location, and with $25,000 seed money from Fred Beltner, began fund-raising for a new building to be located in Oregon Trail Park in Gering. The new North Platte Valley Museum opened June 14, 1974, at Eleventh and J Streets. The organization's mission to collect, preserve, and interpret artifacts, documents, and published materials relating to the North Platte Valley heritage remains the same to this day. North Platte Valley Museum's exhibits tell the story of the Plains Indians, trappers and fur traders, the westward migration, and the settlement and growth of the North Platte Valley. The archive at North Platte Valley Museum houses the nationally recognized Paul and Helen Henderson Oregon Trail Collection and the locally important A. B. Wood and George Mark Collection, as well as priceless photographs and oral histories that record a bygone era. Pictured above from the left are the Gentry log house, the Fort Sidney jail, and the Thomas soddy. The cabins are authentic structures used by the Gentry and Thomas families and moved to the North Platte Valley Museum grounds.

Across America, People are Discovering Something Wonderful. Their Heritage.

Arcadia Publishing is the leading local history publisher in the United States. With more than 3,000 titles in print and hundreds of new titles released every year, Arcadia has extensive specialized experience chronicling the history of communities and celebrating America's hidden stories, bringing to life the people, places, and events from the past. To discover the history of other communities across the nation, please visit:

www.arcadiapublishing.com

Customized search tools allow you to find regional history books about the town where you grew up, the cities where your friends and family live, the town where your parents met, or even that retirement spot you've been dreaming about.